MAGIC DOORS

"I only went out for a walk and finally concluded to stay out till sundown, for going out, I found, was really going in."
John Muir

by John Pearson

Addison-Wesley Publishing Company

Reading, Massachusetts • Menlo Park, California • London • Amsterdam • Don Mills, Ontario • Sydney

Library of Congress Cataloging in Publication Data

Pearson, John, 1934-
 Magic doors.

 Bibliography: p.
 1. Photography, Artistic. 2. Pearson, John, 1934-
 I. Title.
TR654.P39 779'.092'4 77-81634
ISBN 0-201-05668-2-H
ISBN 0-201-05669-0-P
ABCDEFGHIJ-UN-7987

Also by John Pearson To Be Nobody Else
 Kiss the Joy as it Flies
 The Sun's Birthday
 Begin Sweet World

Design by Jaren Dahlstrom, Crow-Quill Studios, San Francisco

To Karen,
my daughter,
my teacher,
and my friend

Sources of the text

Page:

6 Several years ago a woman gave me a piece of driftwood with this quote woodburned into it. She handed it to me after a slide presentation, and then she disappeared. I don't know who wrote the quotation, and don't know the woman. I hope this book finds its way to her after all this time.

13 Gabriel Marcel

21 Anais Nin, *The Diary of Anais Nin, 1931-1934,* The Swallow Press and Harcourt, Brace & World, Inc., 1966.

26 Anais Nin, *A Woman Speaks,* edited by Evelyn J. Hinz, The Swallow Press, 1975.

33 Henry Miller, *Big Sur and the Oranges of Hieronymus Bosch,* New Directions Publishing Co. 1957.

34 Henry Miller, *Plexus,* Grove Press, 1965.

46 John Pearson

51 Henry Miller, *Big Sur and the Oranges of Hieronymus Bosch*

57 John Pearson

65 Shunryu Suzuki, *Zen Mind, Beginner's Mind,* John Weatherhill, Inc., 1973.

76,78 Orpingalik, Eskimo poet in *Eskimo Realities* by Edmund Carpenter, Holt, Rinehart and Winston, 1973.

80-81 Photo by Robert Routch.
Just when I was looking for a picture that might go with this quote, Bob Routch, a good friend and fantastic French horn player, came to visit and brought this photograph of lightning which he took eight years ago in Florida.

80-92 John Muir, unpublished journal, *John of the Mountains*

Introduction

I am constantly surprised by the diversity and beauty in the world. This book is an attempt to share the magic of people, places, and things of my everyday life.

For me, photography has become a process of discovery. Whenever I go out to photograph, I never know what I will see. So I wander and look until I'm moved by something: a rose, a gesture, a woman fishing. In my life and photography, I am drawn to people who feel intensely. When someone is involved with another person, lost in music, or exploring an inner mood, that's when I photograph.

Sometimes I think I've taken a picture of one thing, but when I see the prints, it becomes something new. A Mexican cathedral at dawn becomes a dream image; a friend in a telephone booth becomes a character in a drama. Sometimes I see something — a cloud formation, a face in a window, a reflection — and have forgotten my camera. But I still delight in seeing, and my eyes click though it's not registered on film.

Working on a book is another kind of discovery. I print pictures that excite me. I begin to select from the hodge-podge of images. Soon a hundred prints cover the living room floor. Some pictures go together naturally: the primitive stare of a stone fish in the San Francisco aquarium resembles that of a carousel horse in a Maine antique shop; the universal gestures of dance are revealed in an Indian dancer and a child dancing on my front porch. Other pictures lie on the floor waiting. Soon patterns begin to emerge. A book begins to form.

My photographs are filed in three categories — nature, art, and people. In working on this book I see more clearly that these divisions are false: everything is intricately related. I rediscover what I thought I already knew: that human beings and all their art, music, sculpture, poetry, dance, and dreams are part of the seamless fabric of nature itself. These pictures have become magic doors for me. I hope they will be for you.

Of magic doors there is this:
you do not see them even as
you are passing through.

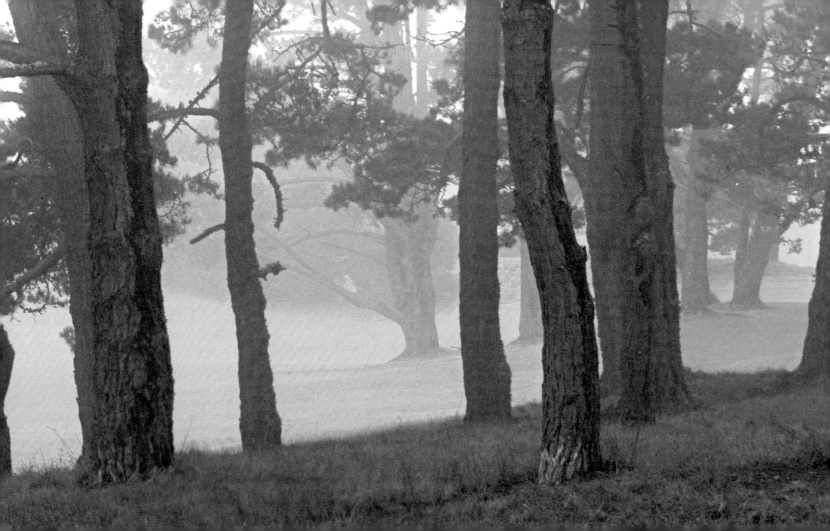

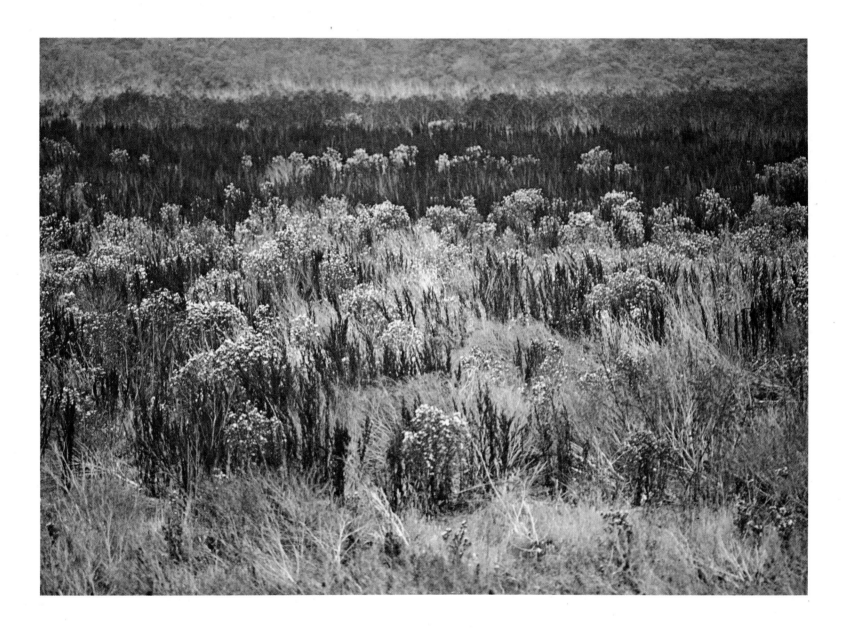

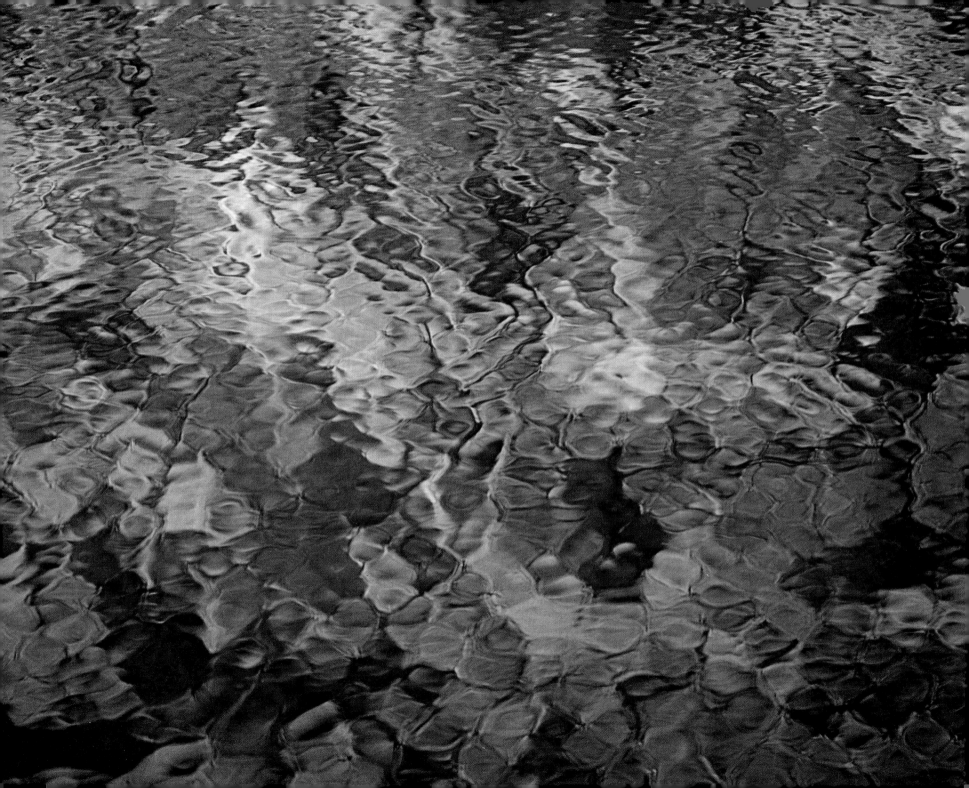

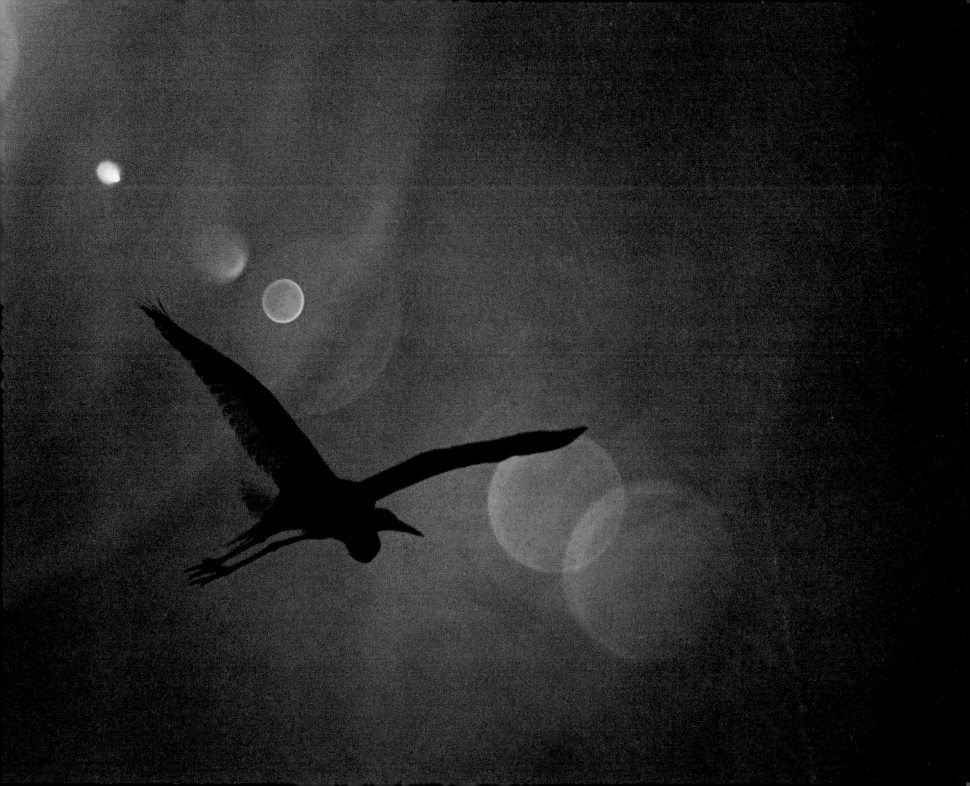

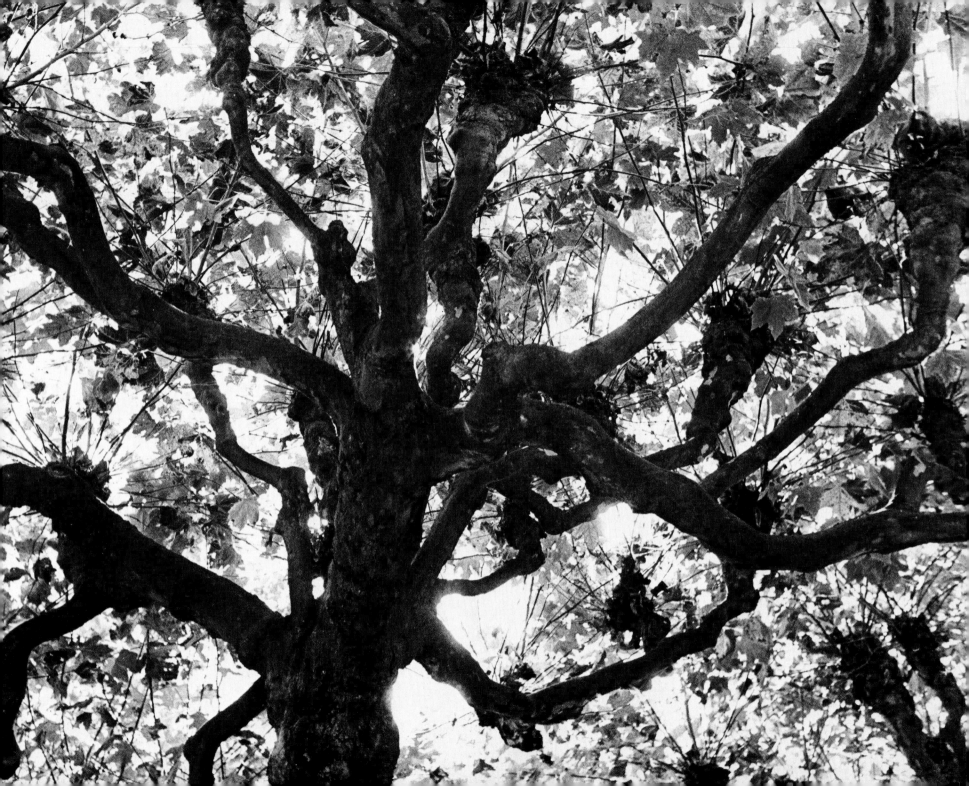

Life is not a series of problems.
It is a network of mysteries.

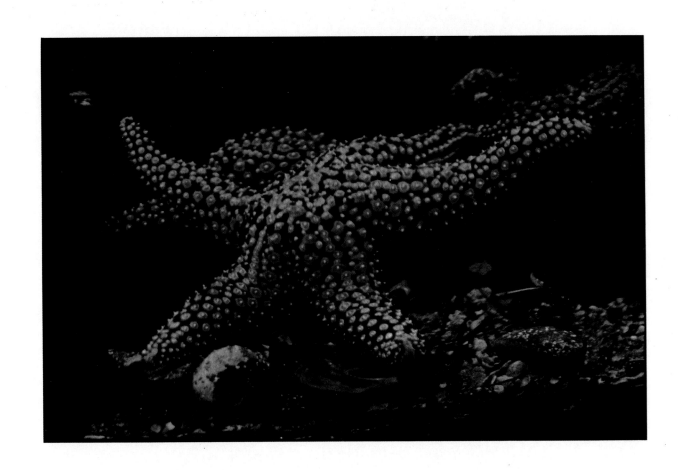

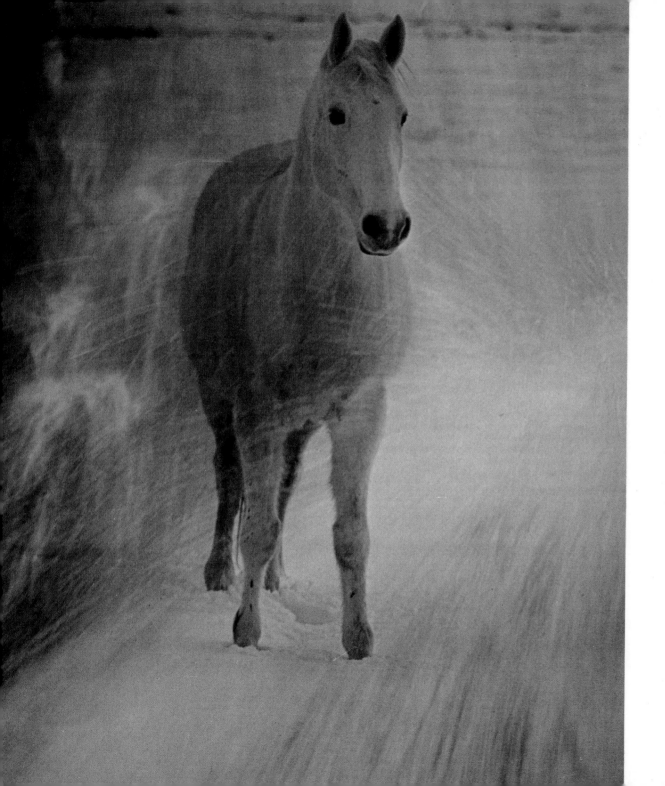

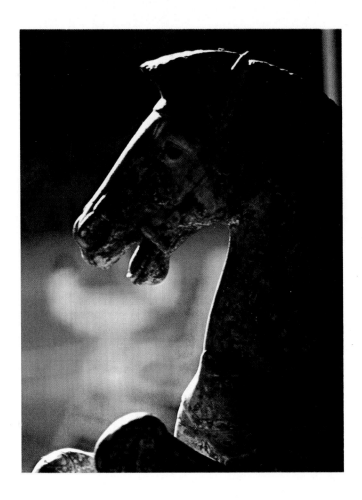

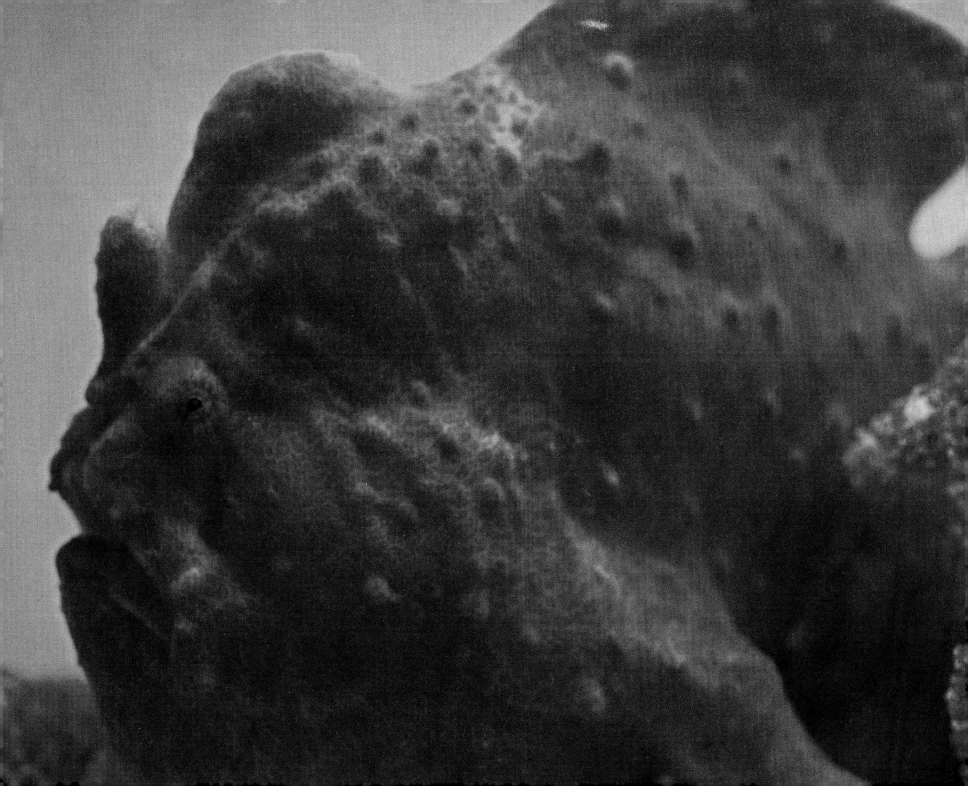

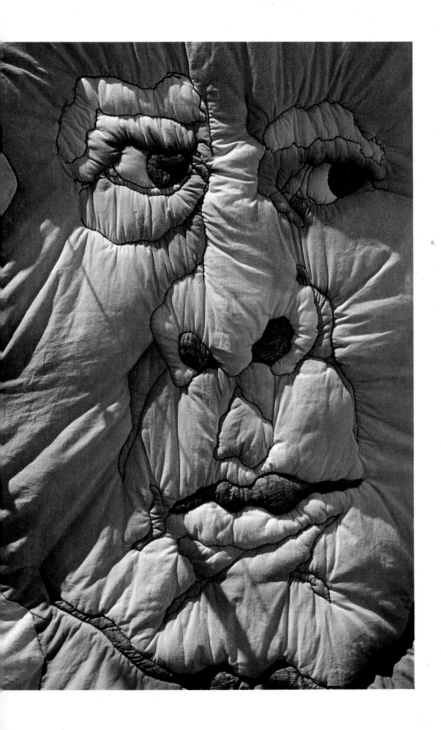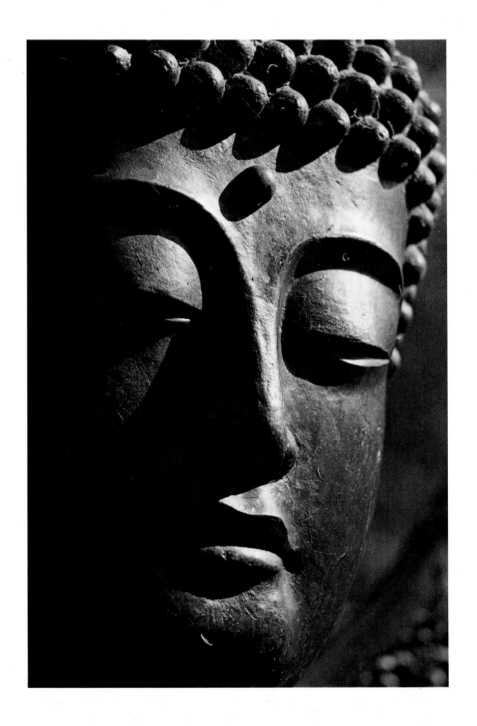

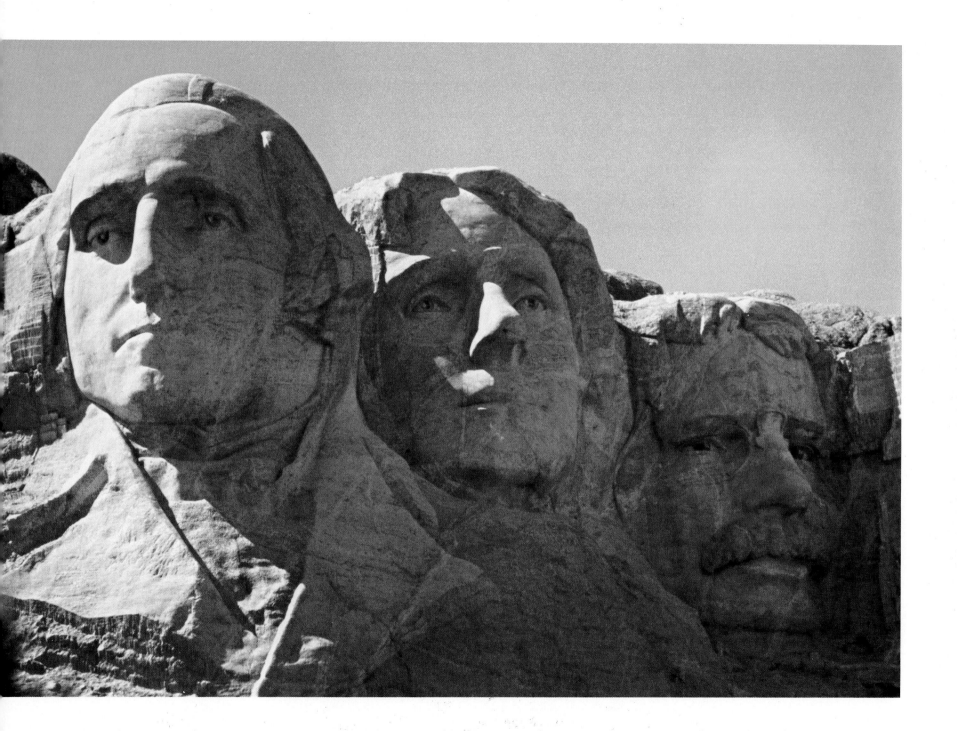

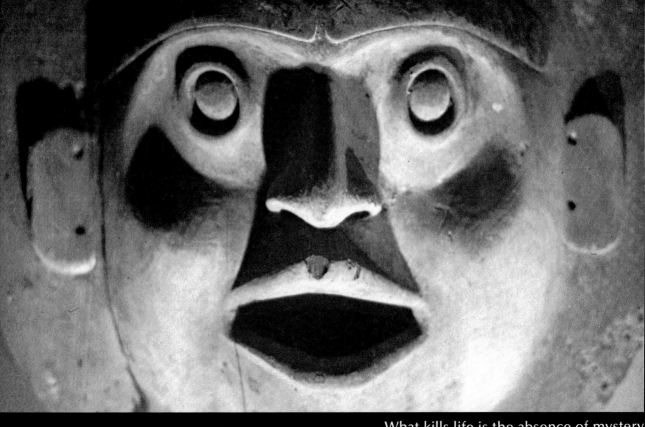

What kills life is the absence of mystery.

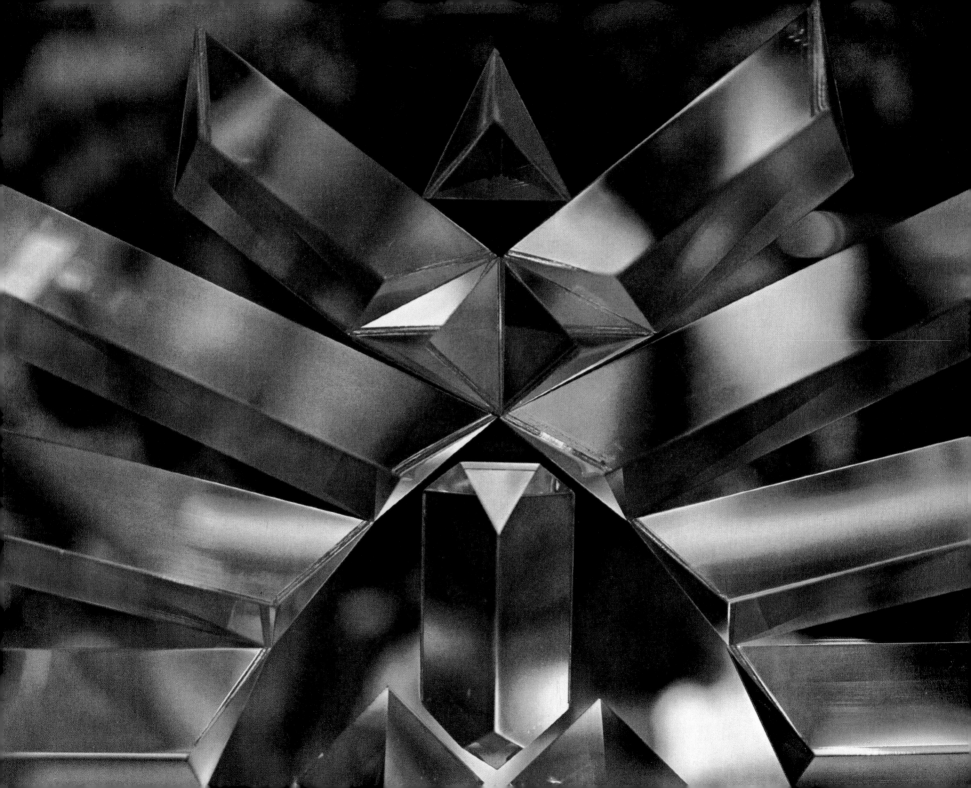

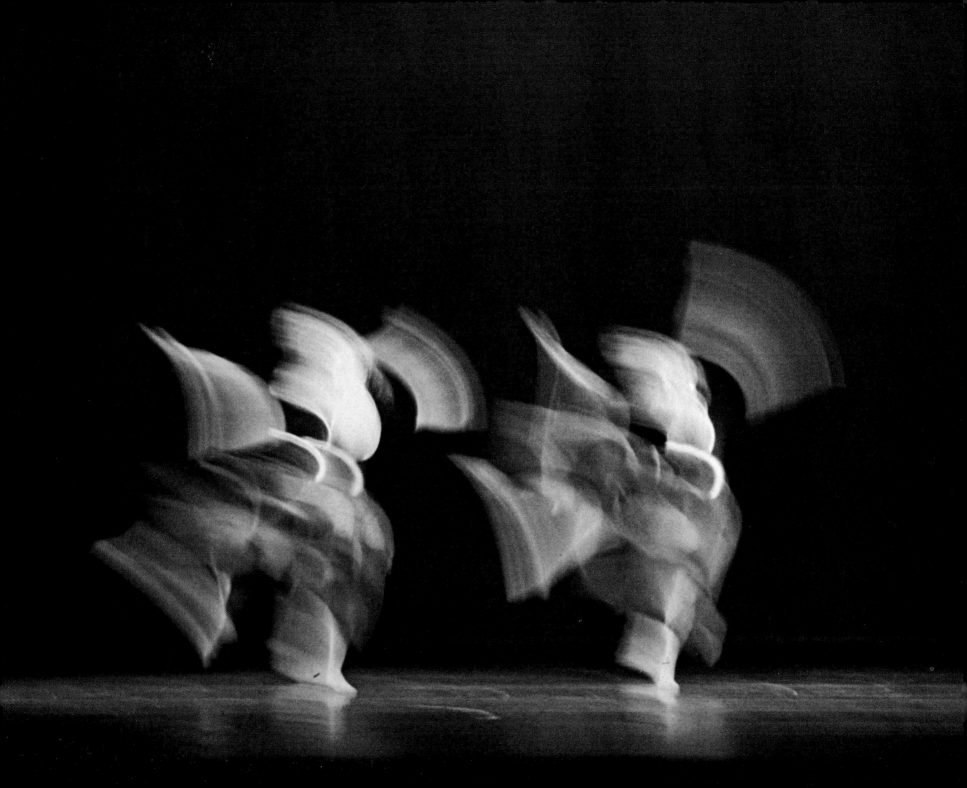

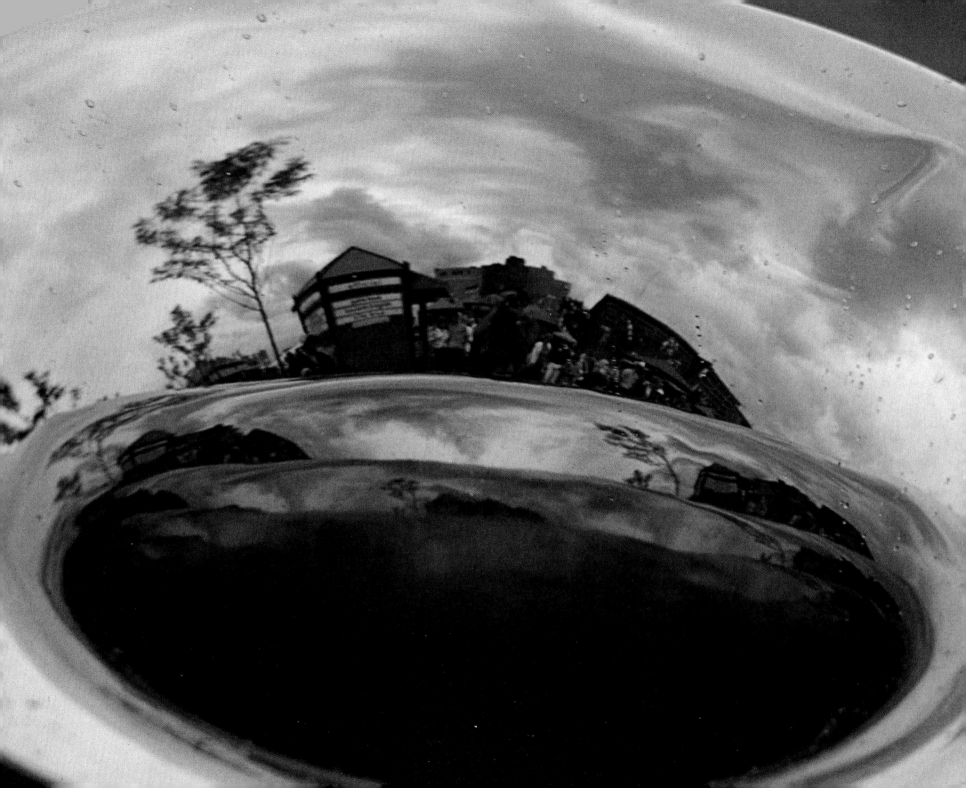

We cannot forget that every one of our lives is an adventure. Part of the growing process demands the inner journey.

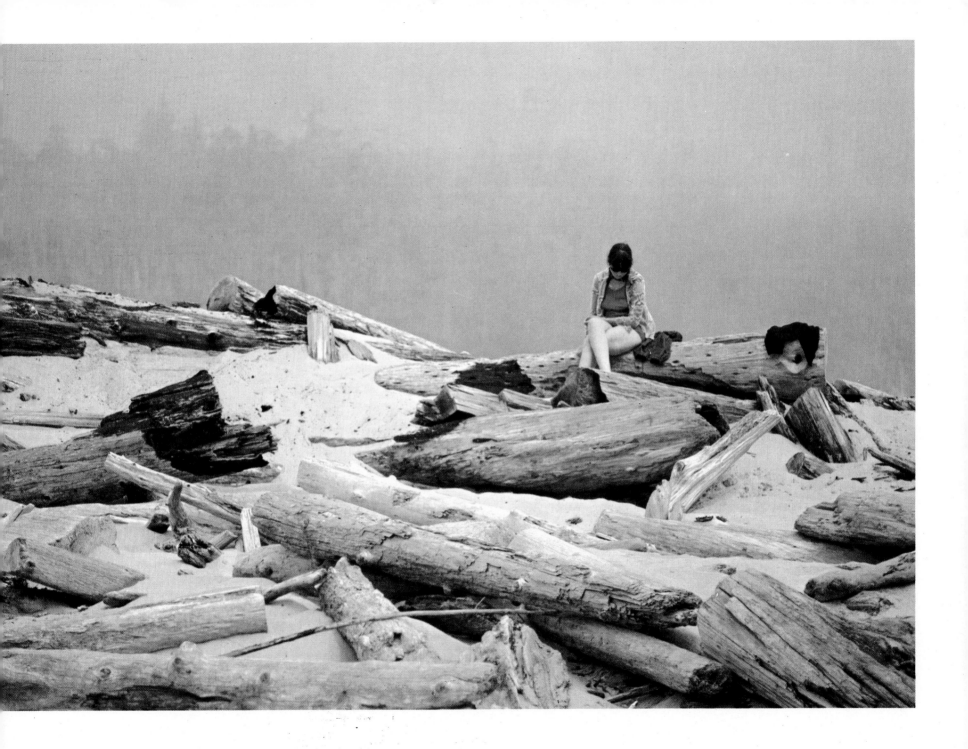

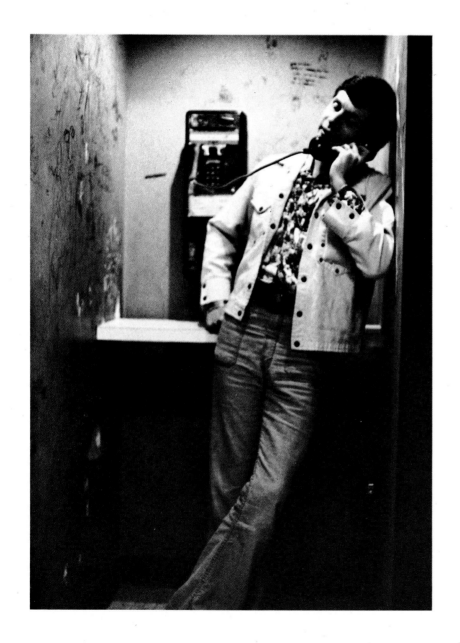
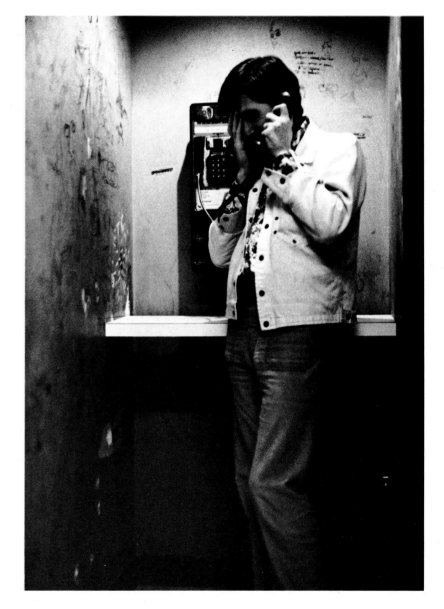

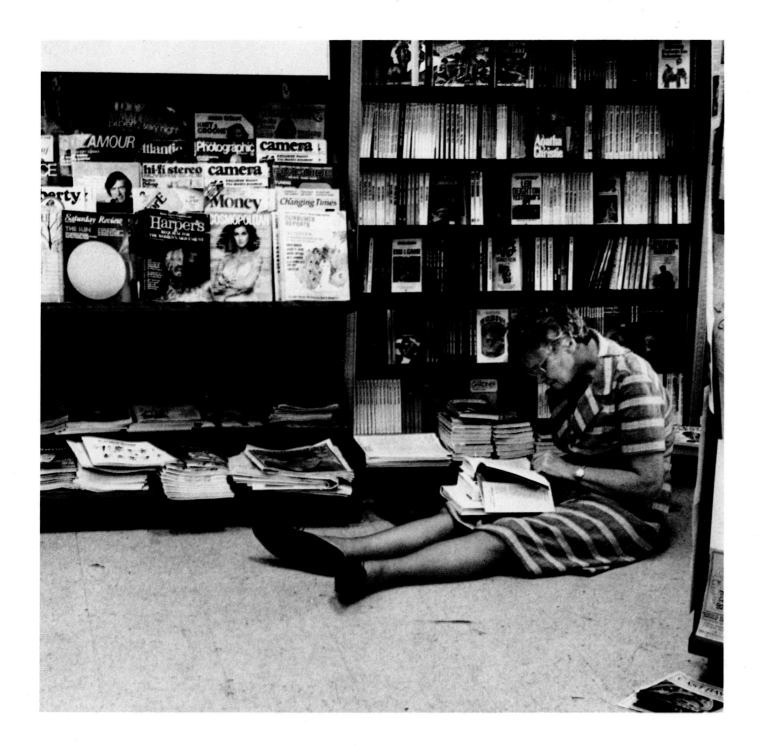

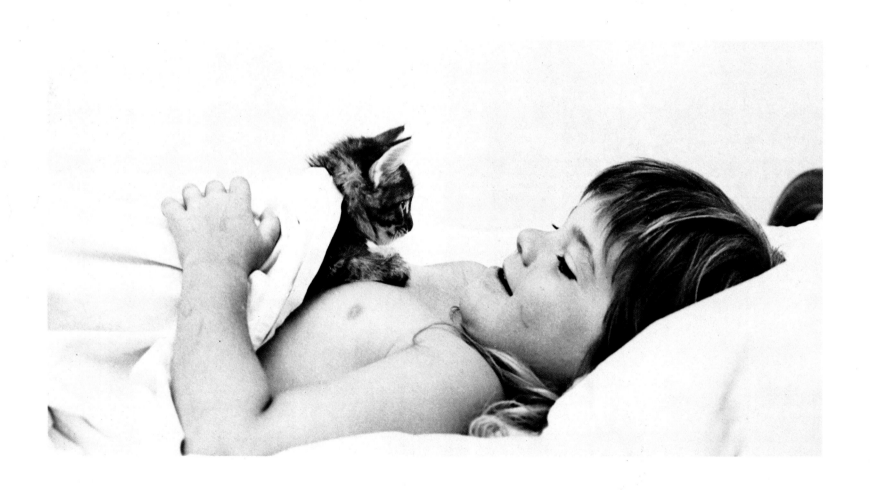

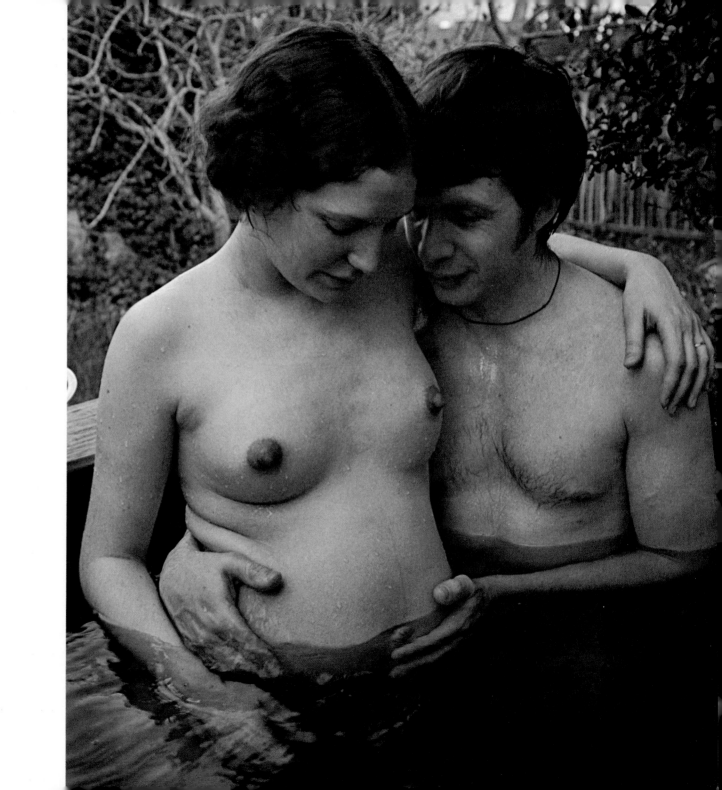

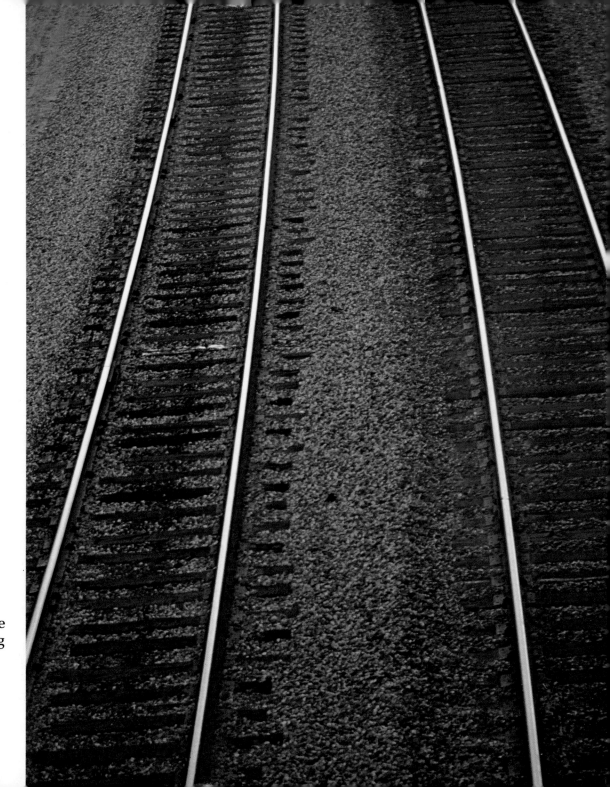

Our destination is never a place
but rather a new way of looking
at things.

The universe swims in light.
Everything is alive and alight. Man
too is the recipient of inexhaustible
radiant energy.

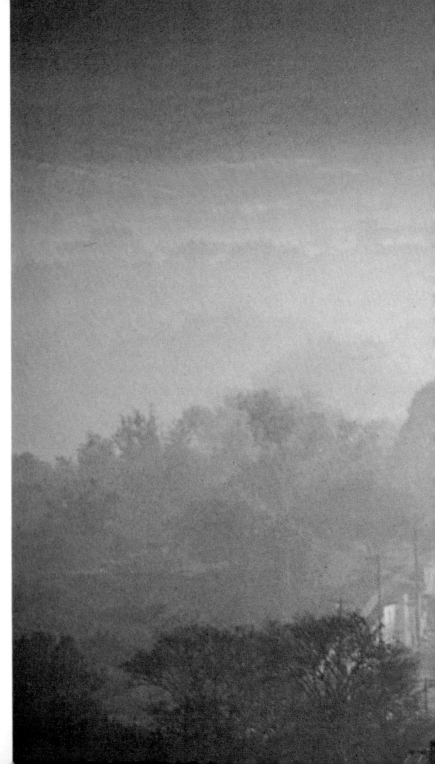

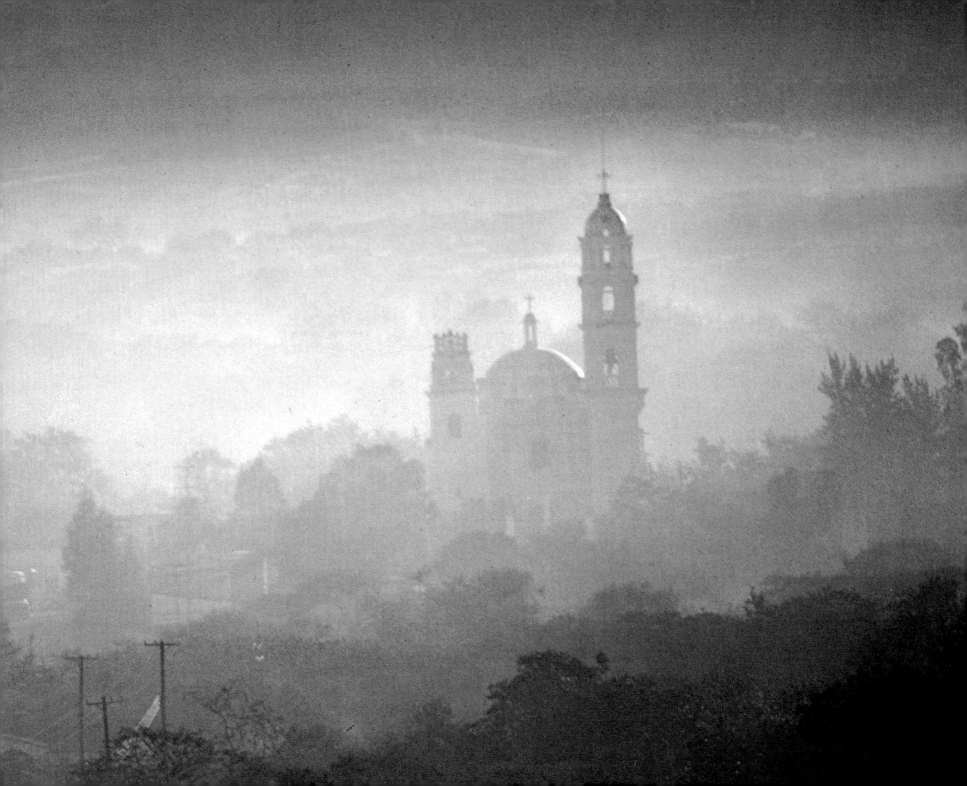

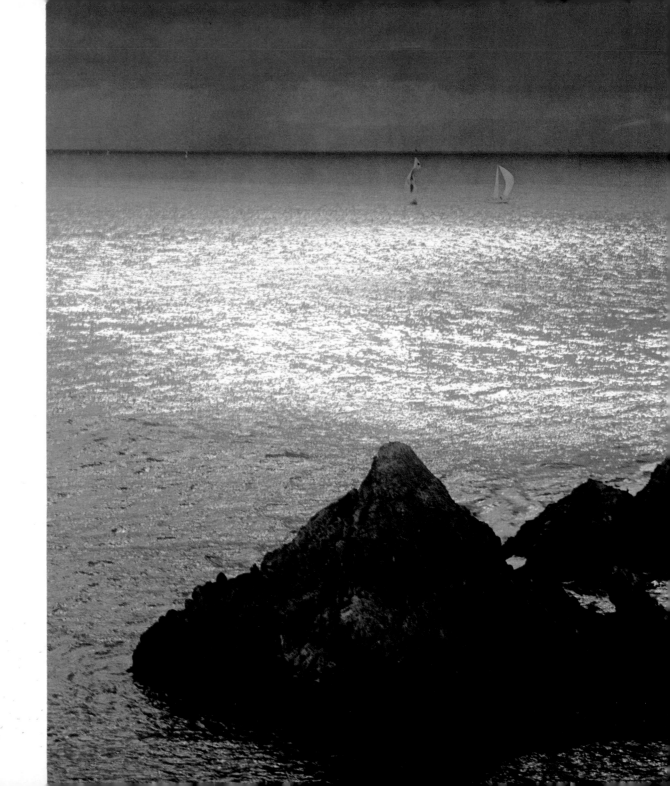

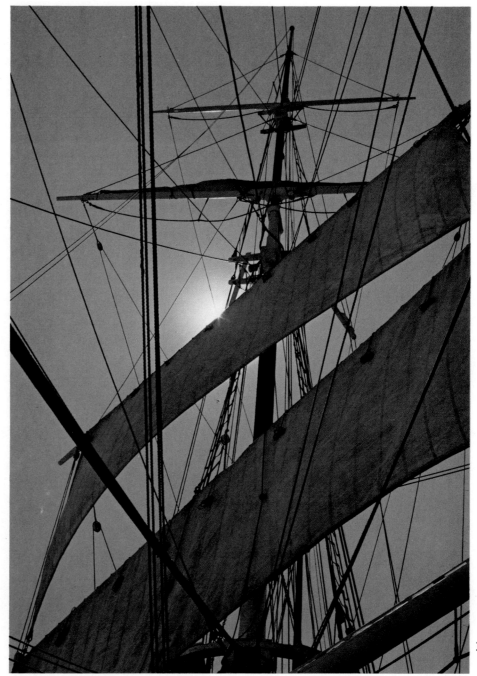

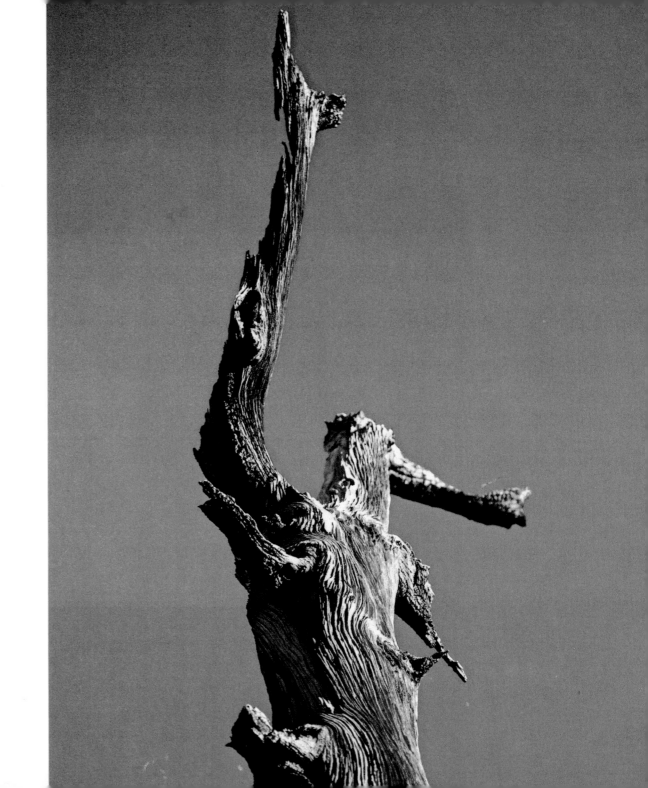

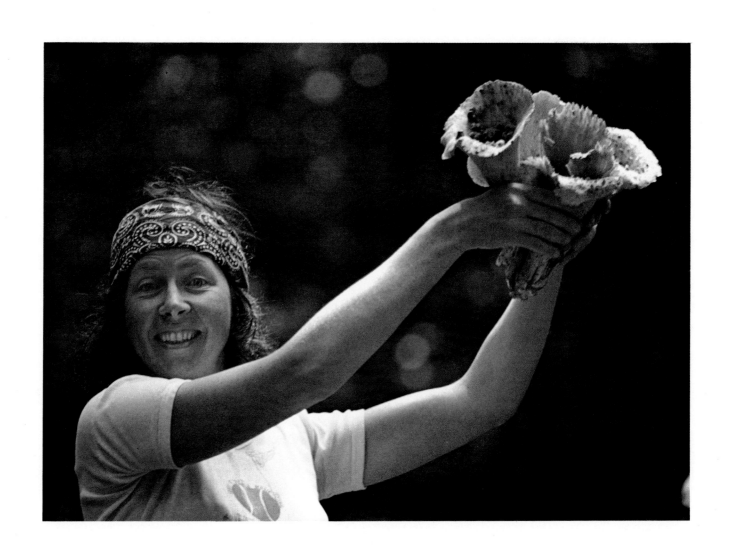

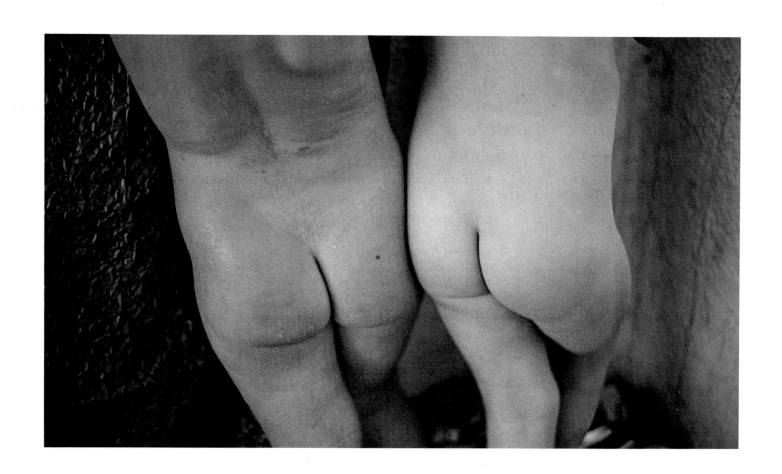

40

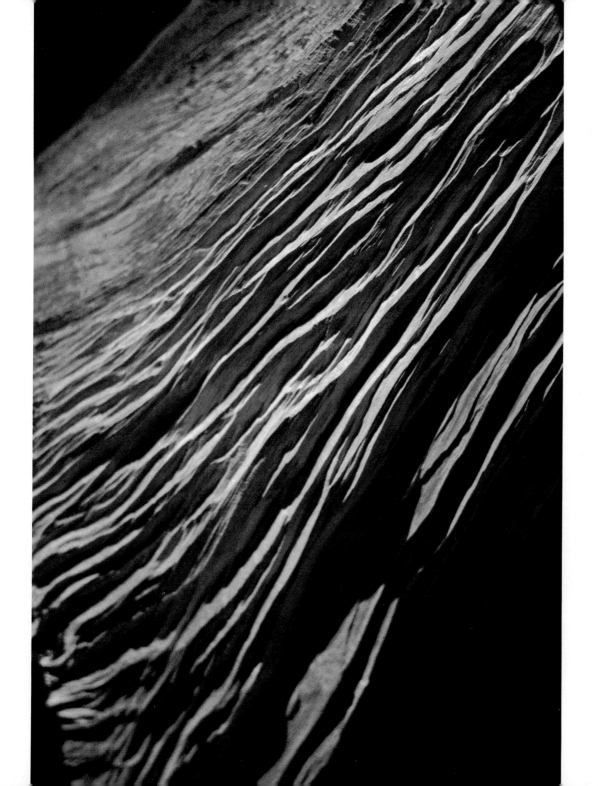

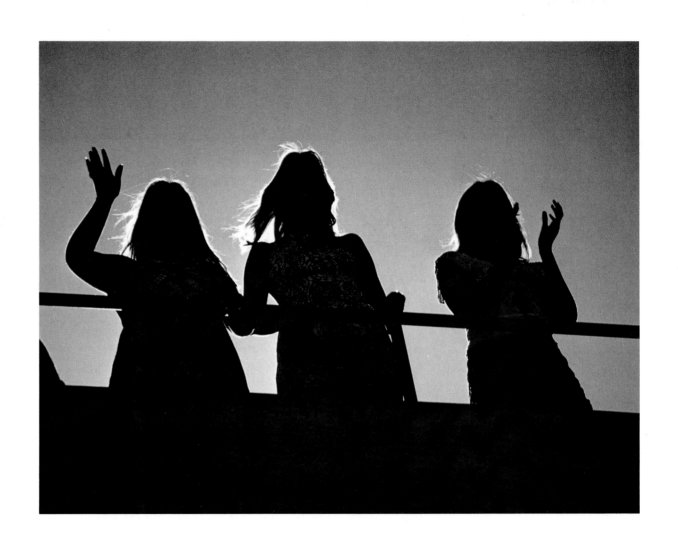

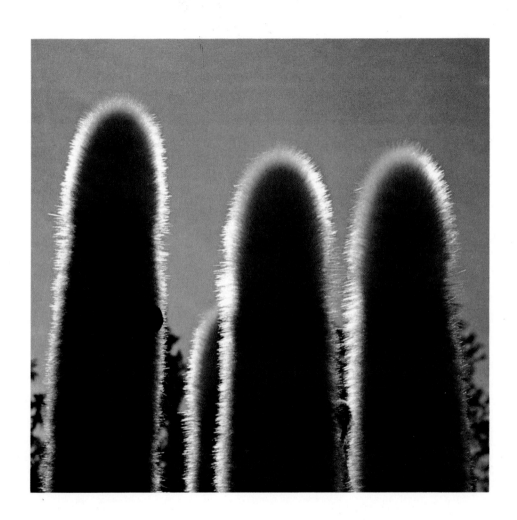

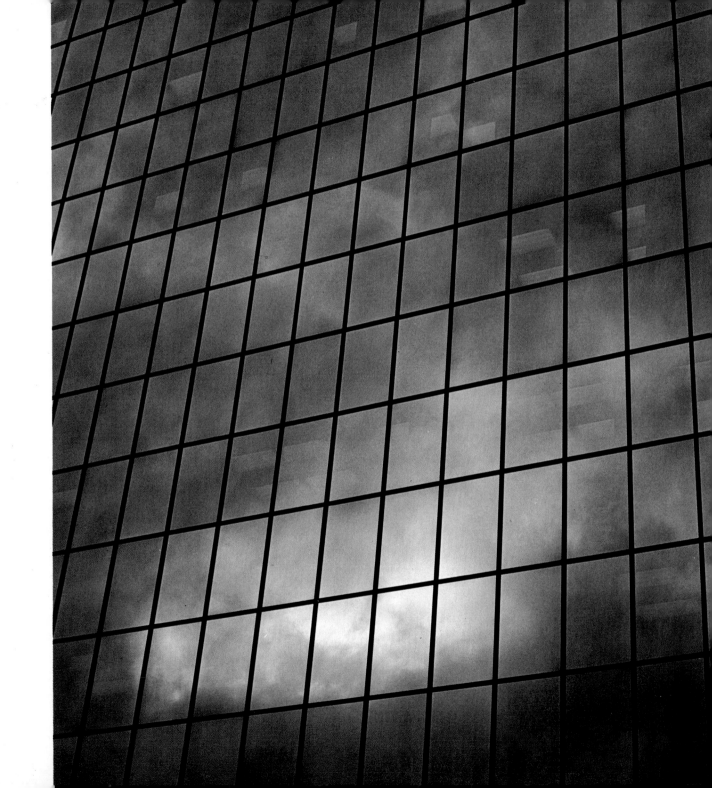

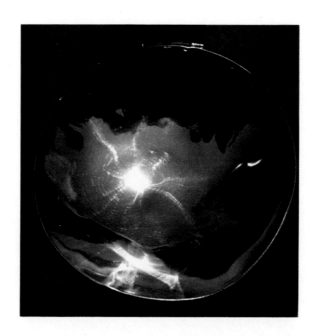

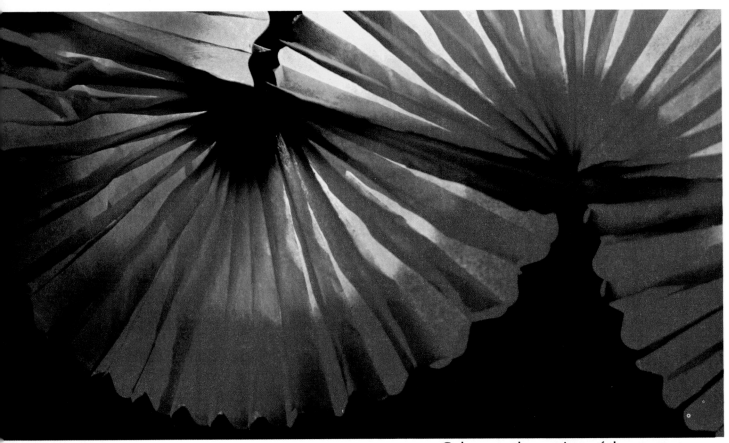

Colors are the ragtime of the cosmos.

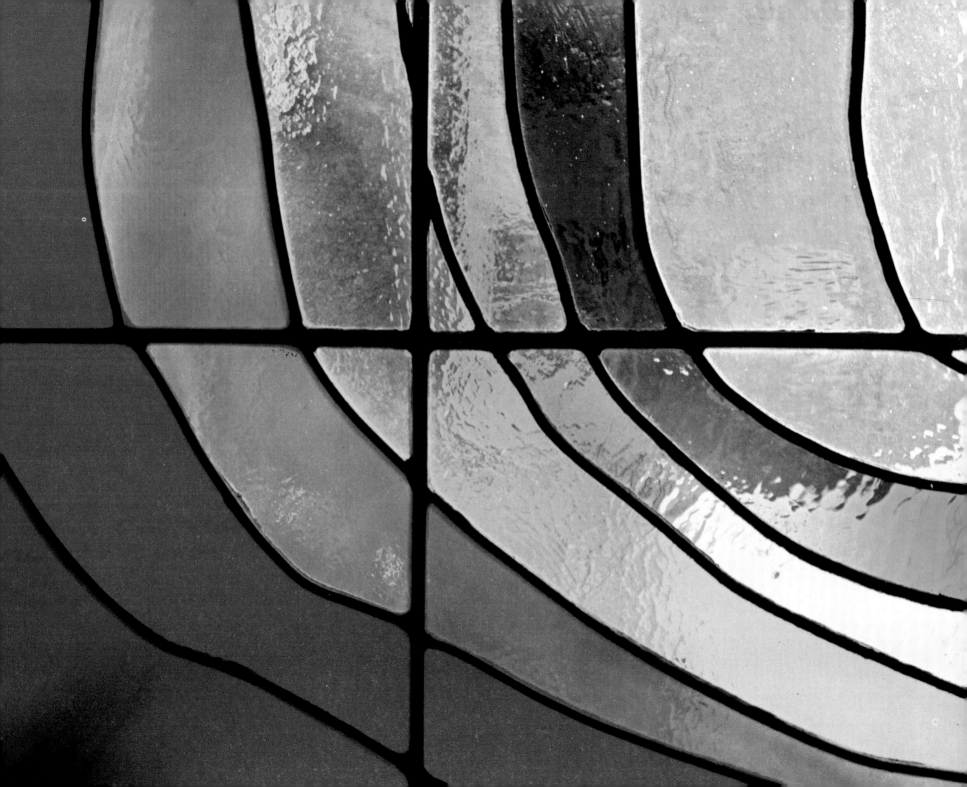

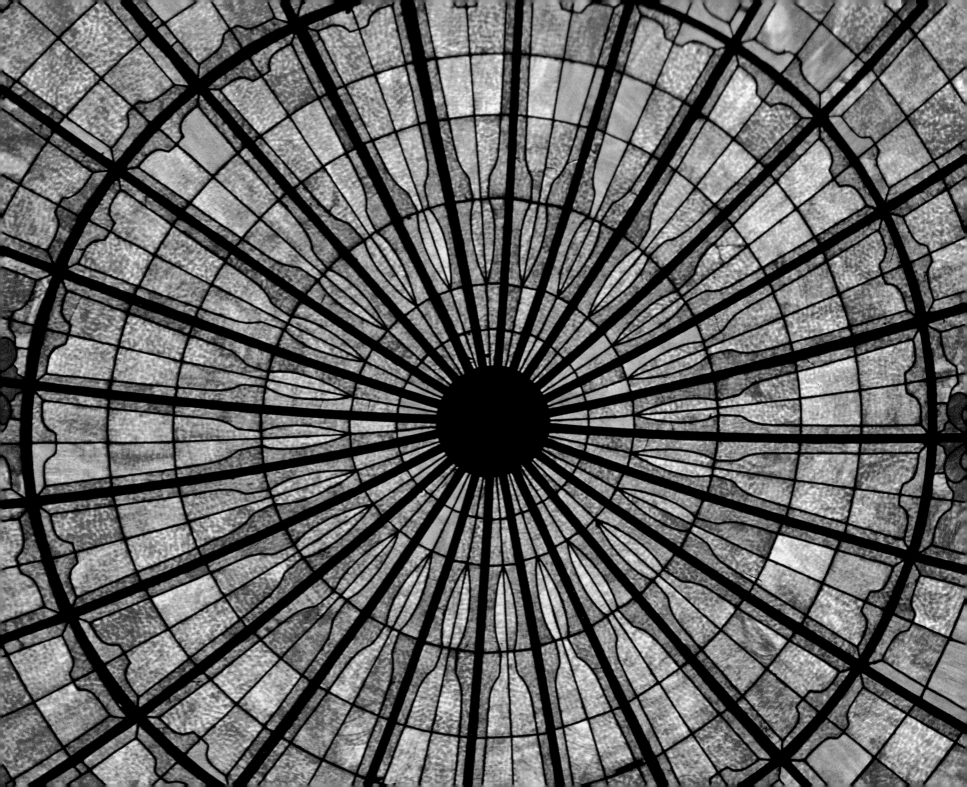

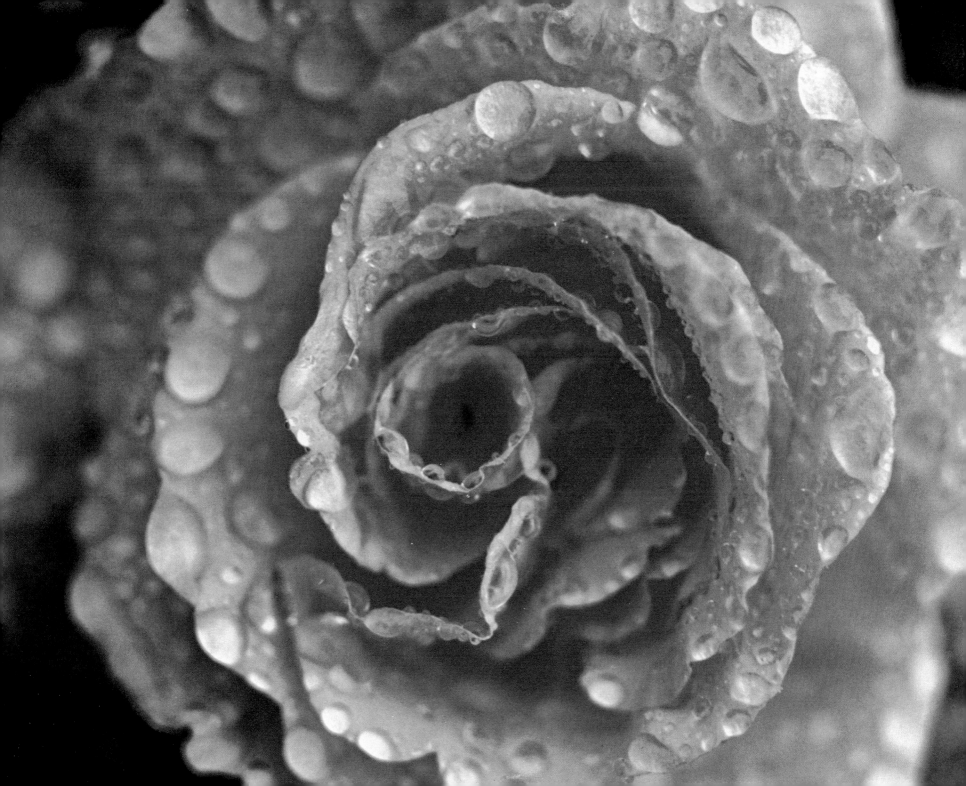

Had we the power to resurrect the dead, what could we offer that life itself had not already offered, and continues to offer, in full measure?

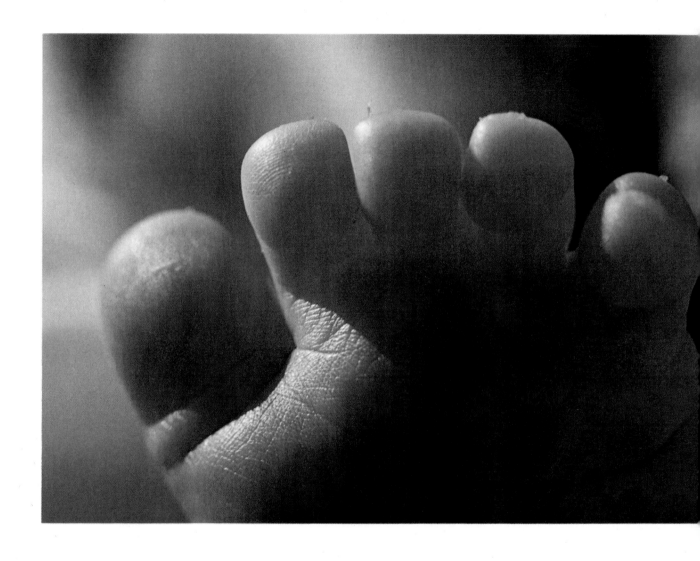

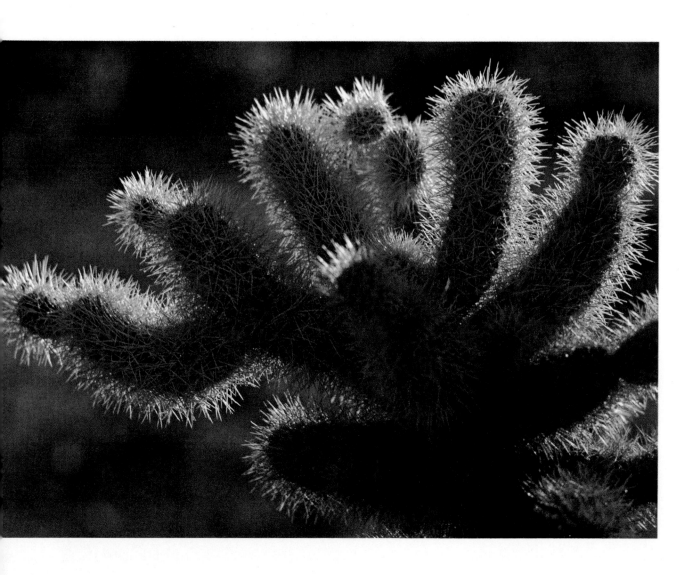

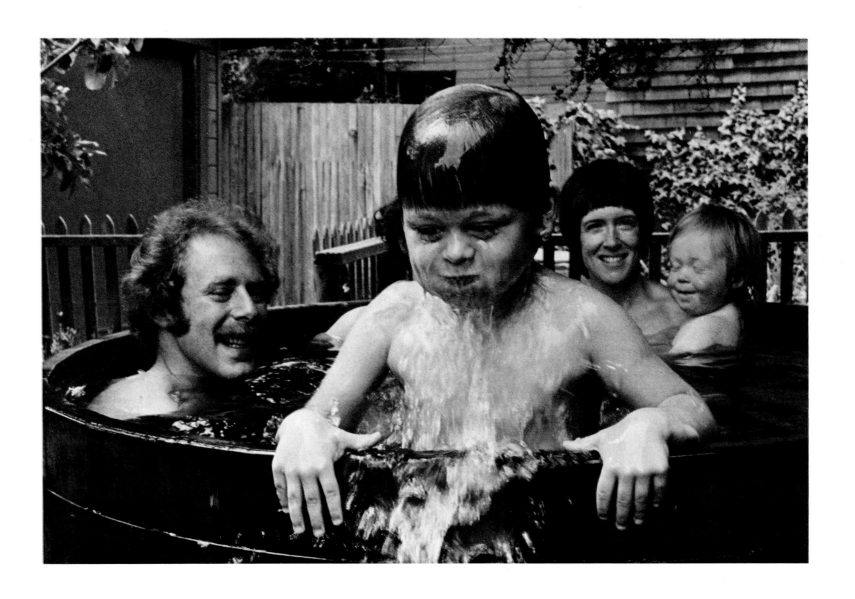

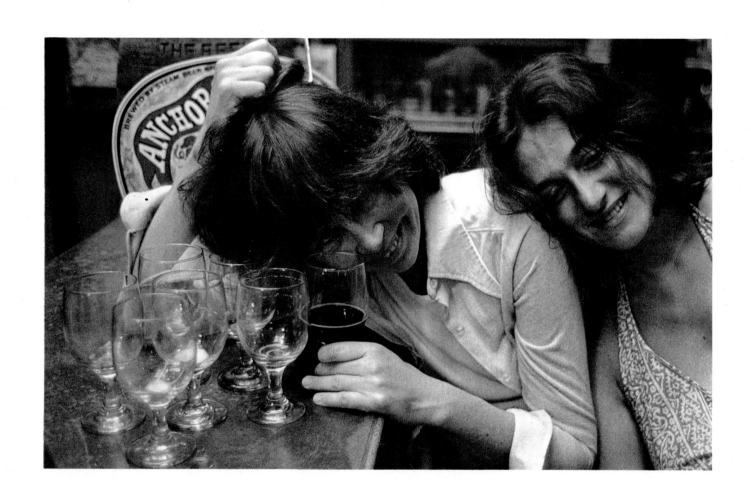

Our life is our most
luminous art form.

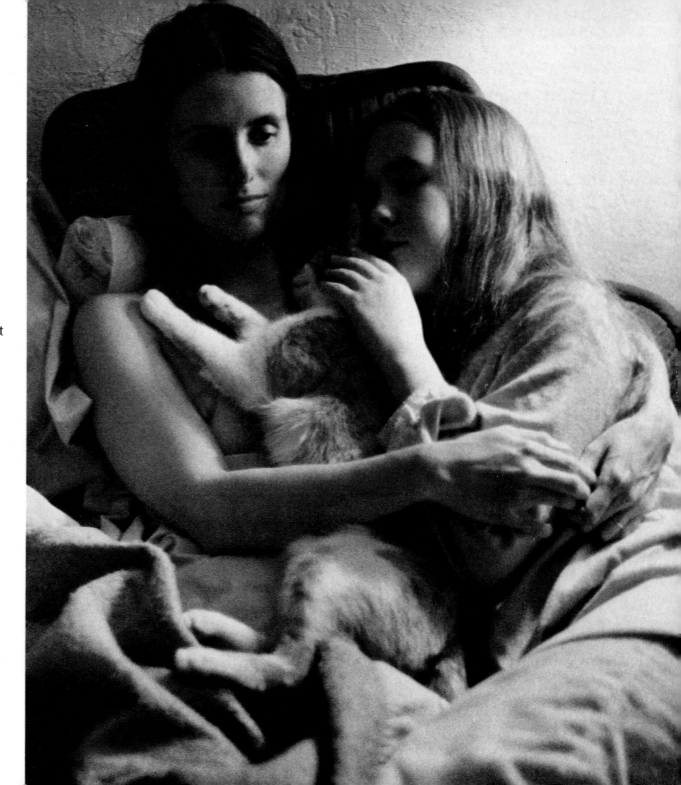

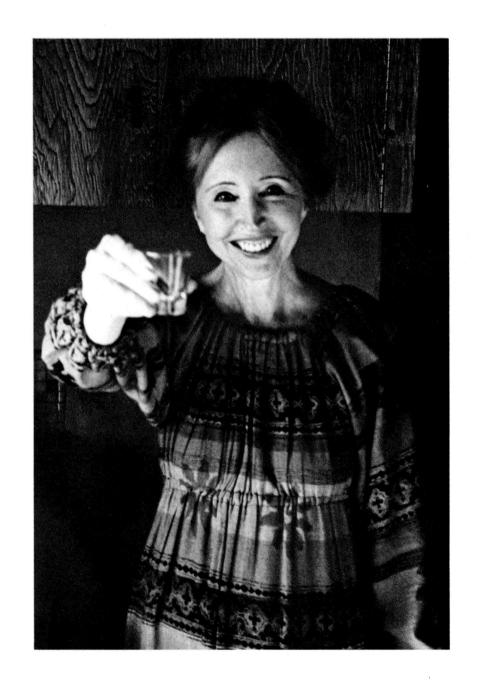

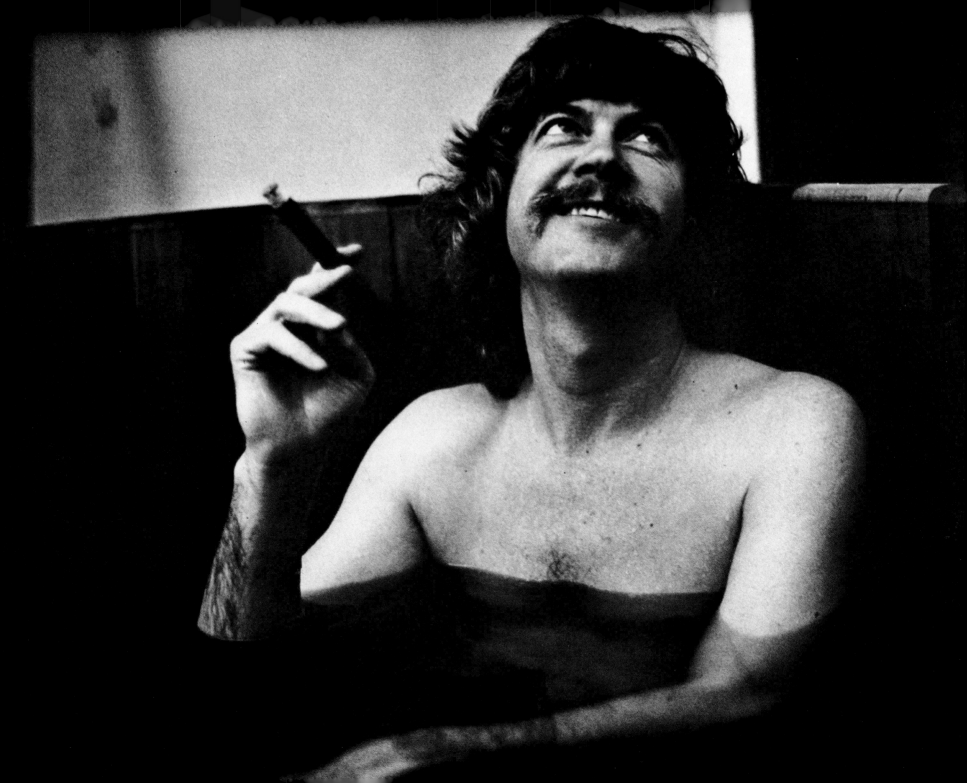

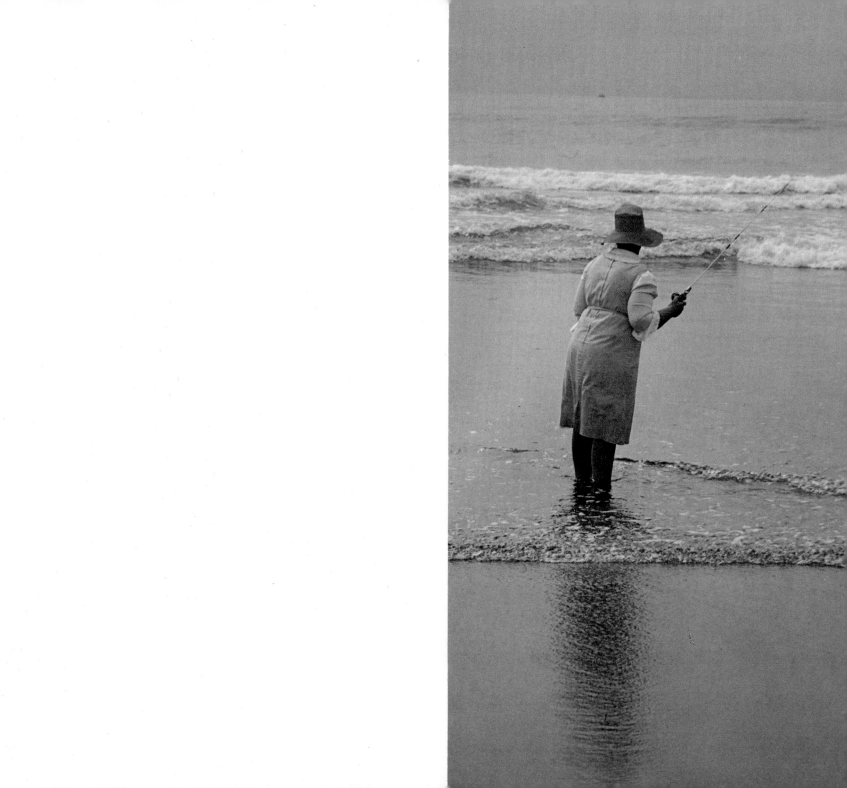

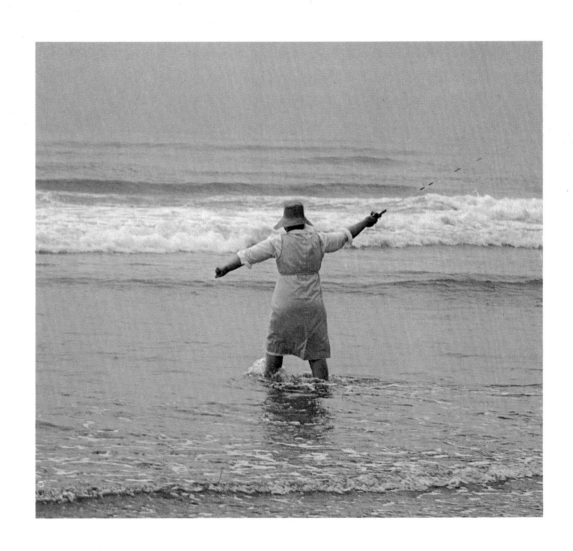

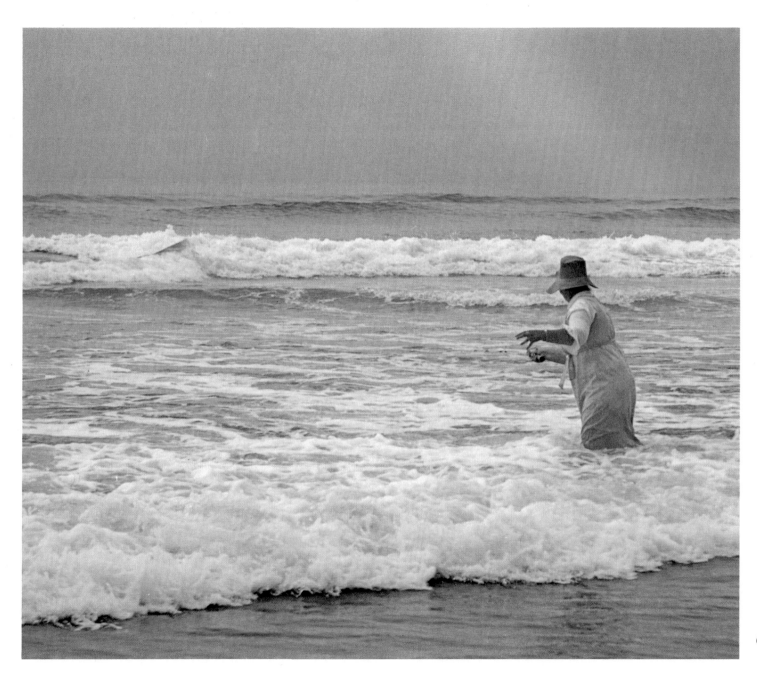

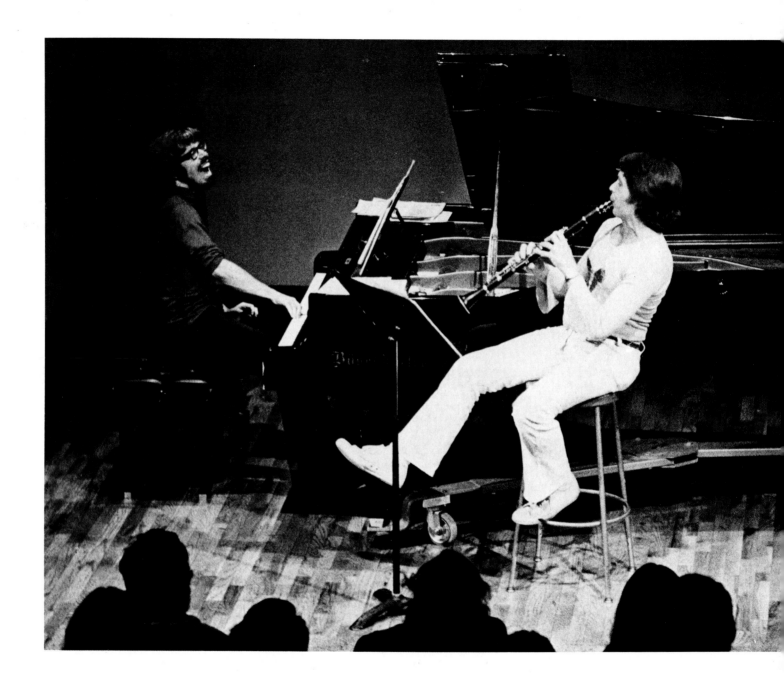

This is the real secret of the arts.
Always be a beginner.

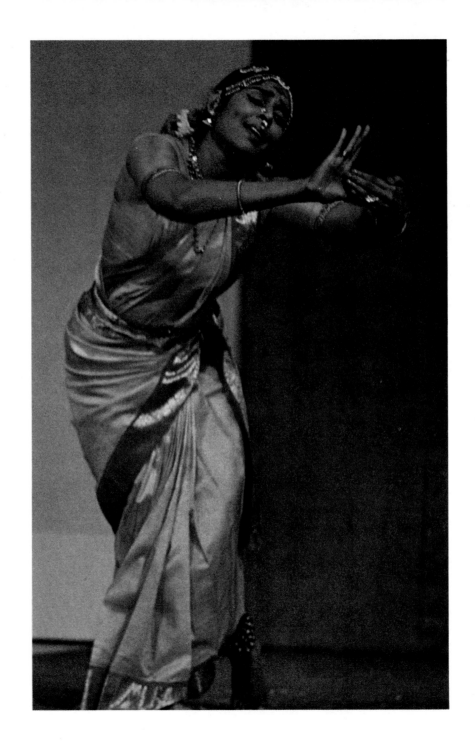

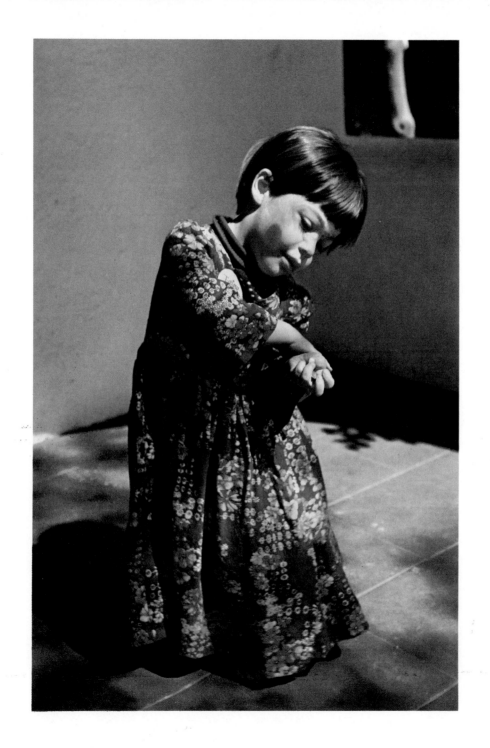

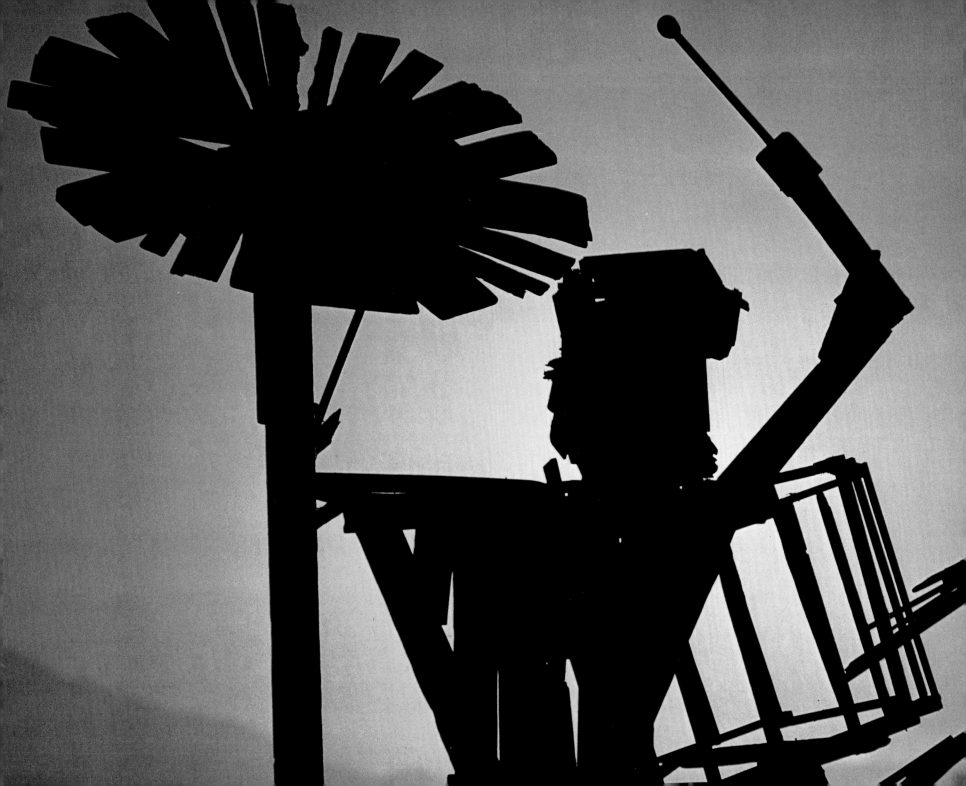

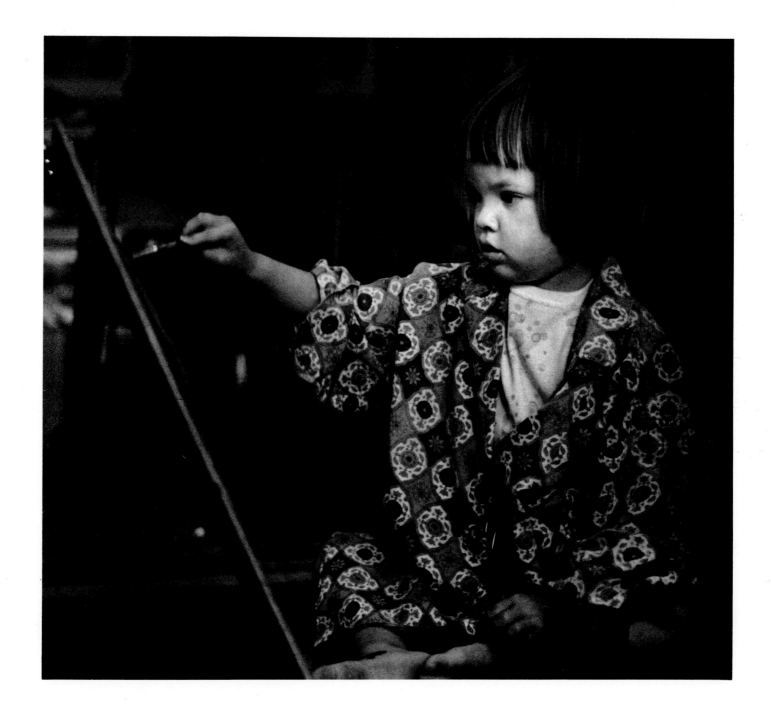

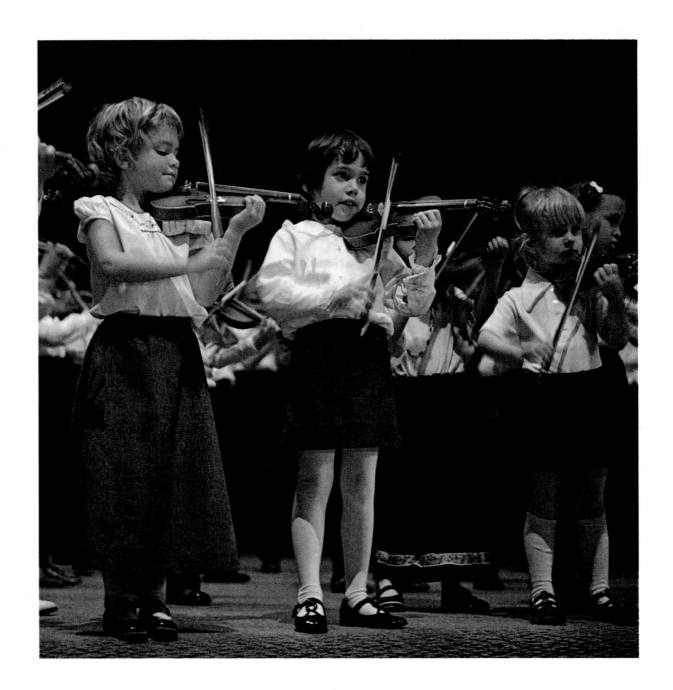

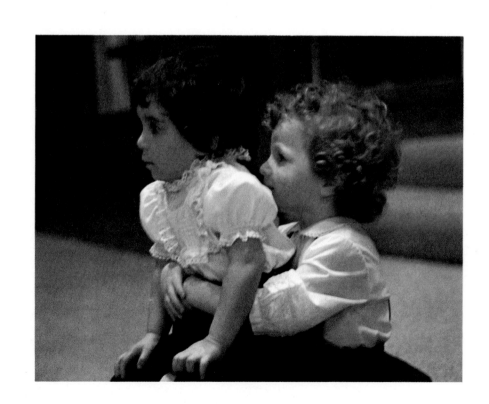

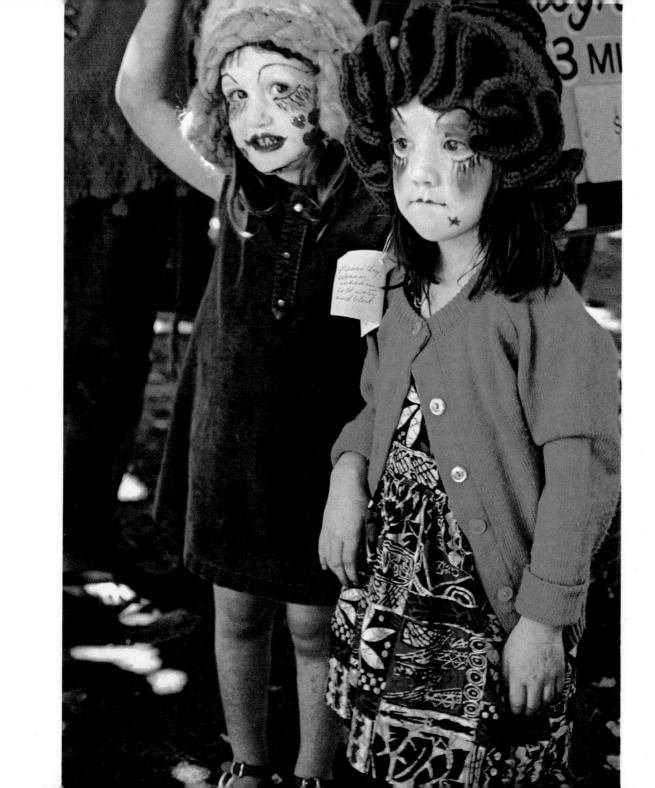

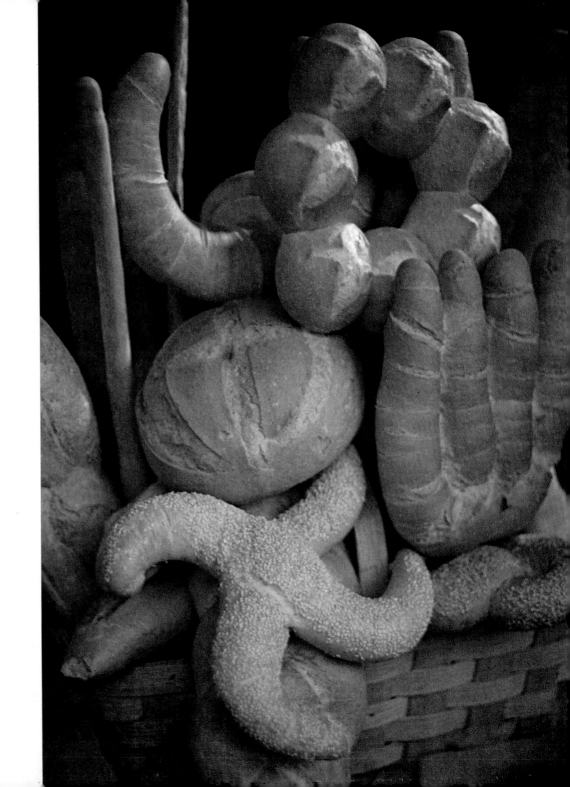

74

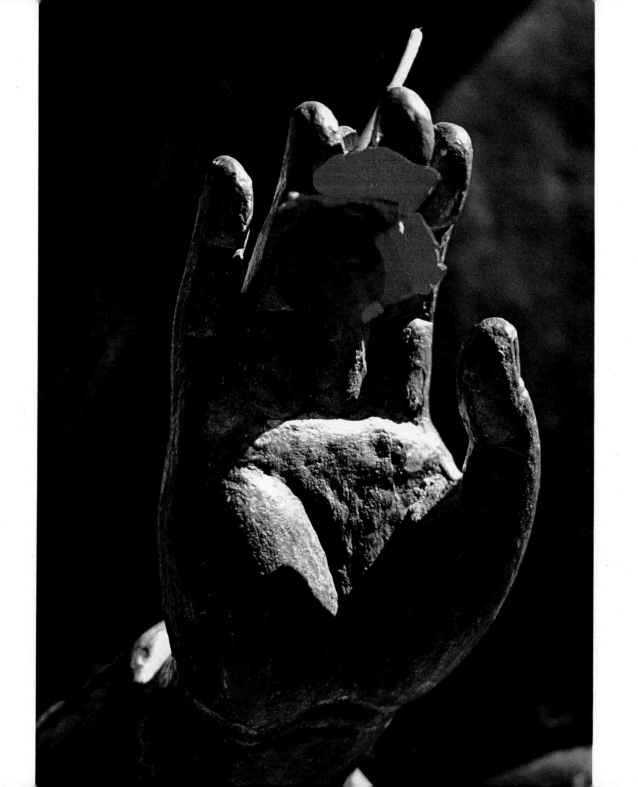

There are so many occasions in one's life
when a joy or sorrow is felt in such a way
that the desire comes to sing; and so I only
know that I have many songs...

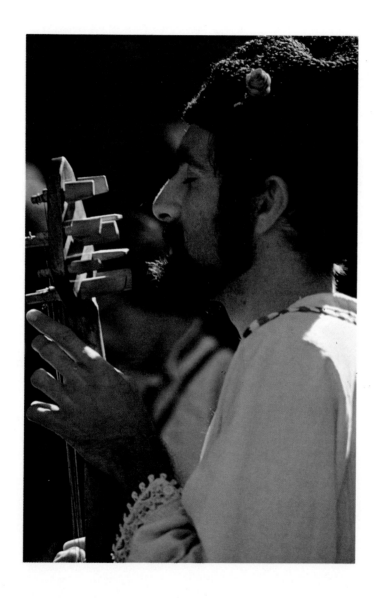

...All my being is song,
and I sing as I draw breath.

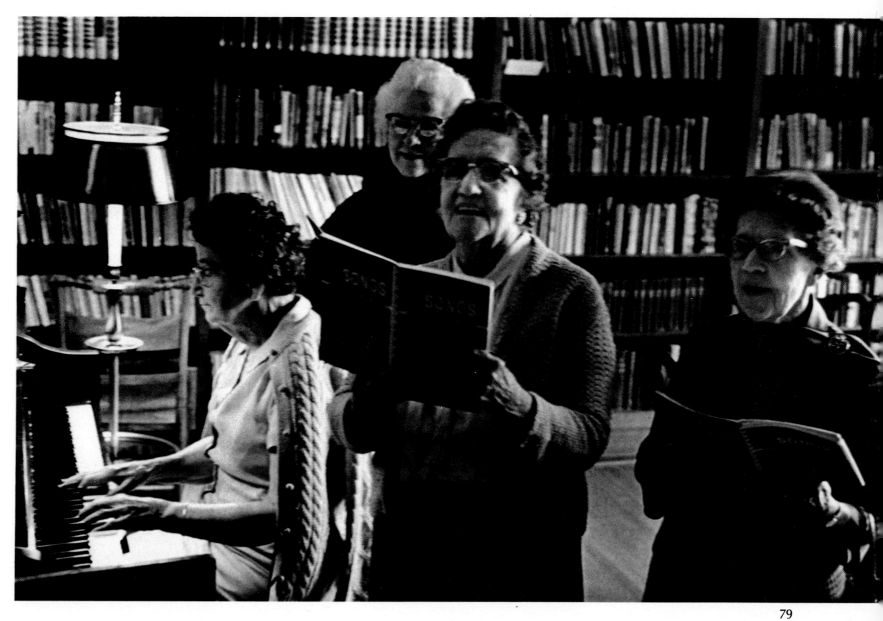

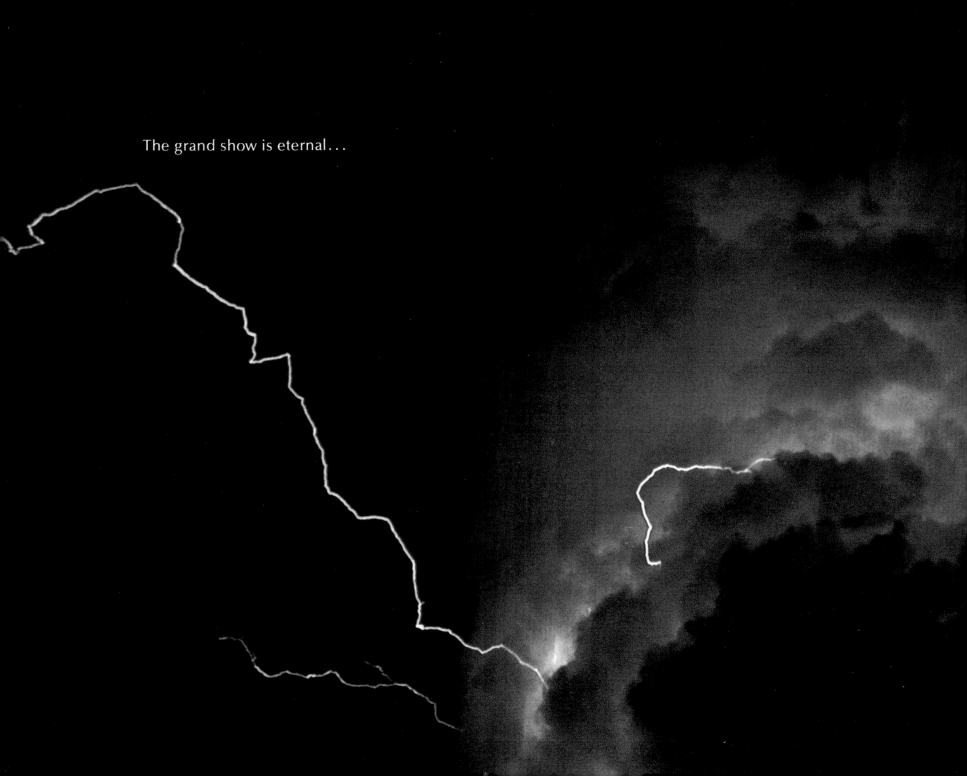

The grand show is eternal...

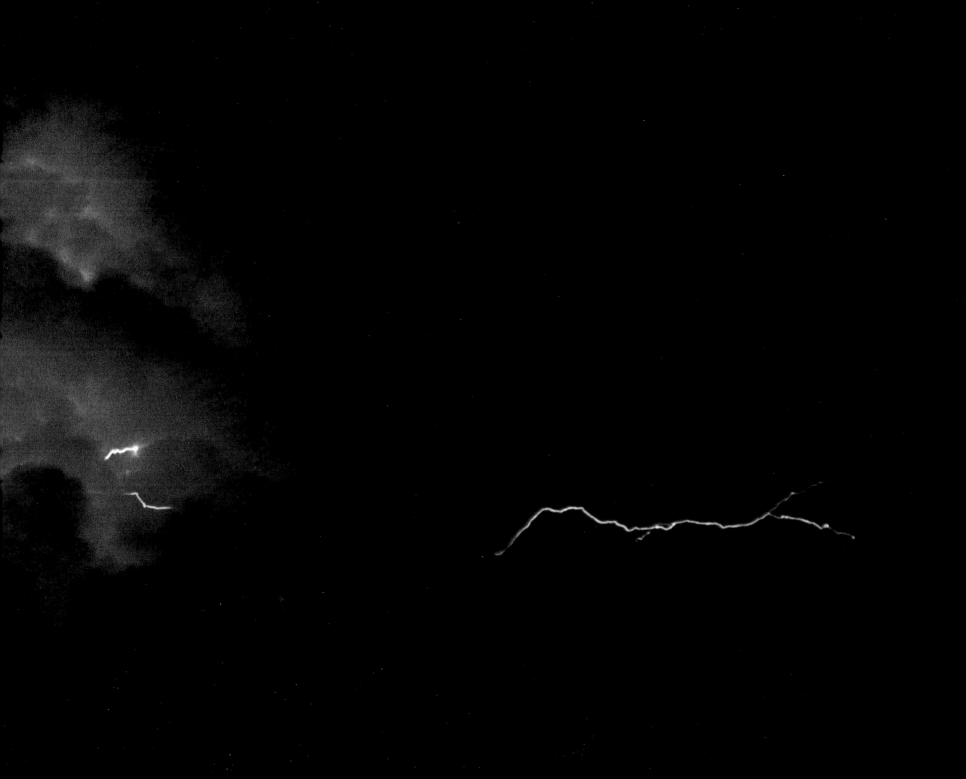

it is always sunrise somewhere;

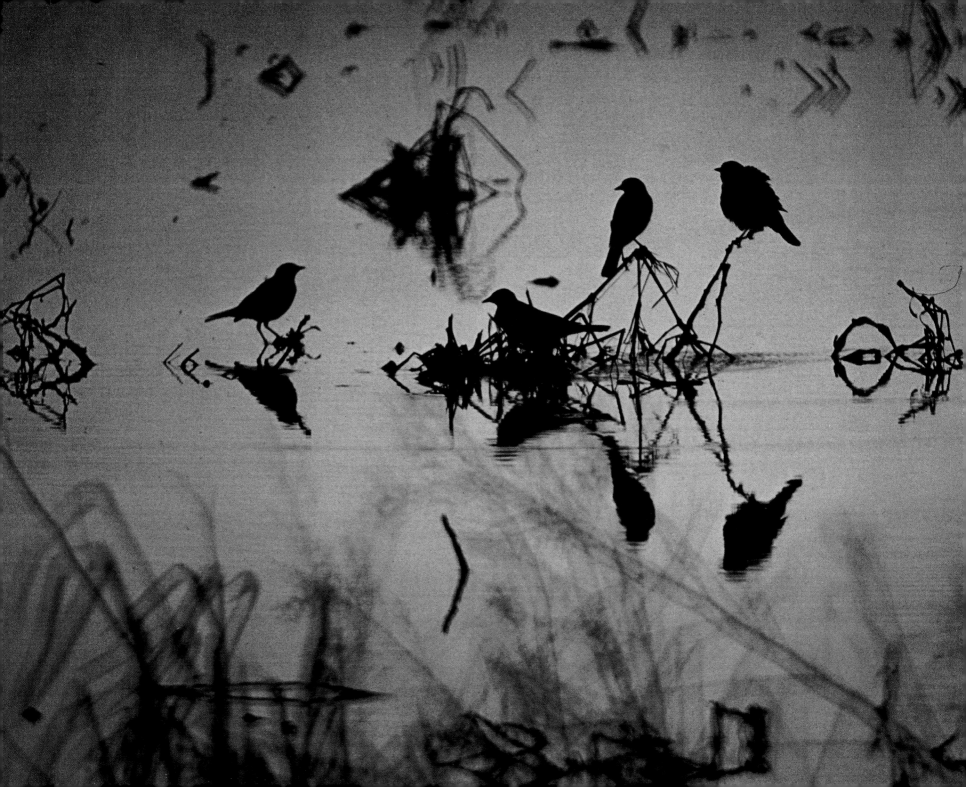

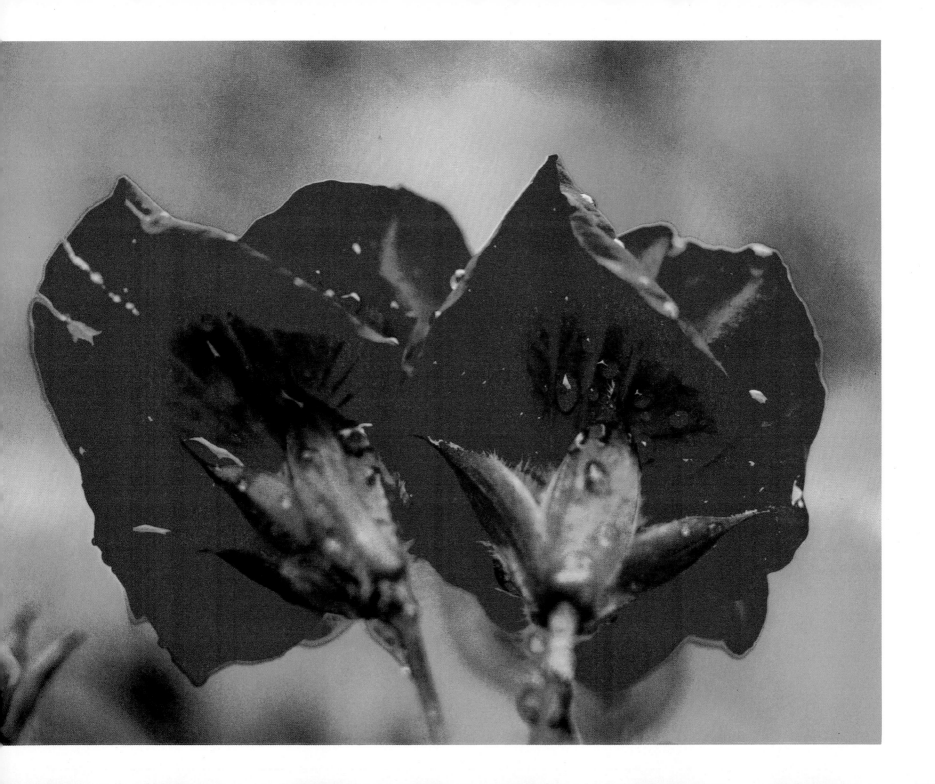

the dew is never all dried at once;
a shower is forever falling;
vapor is ever rising...

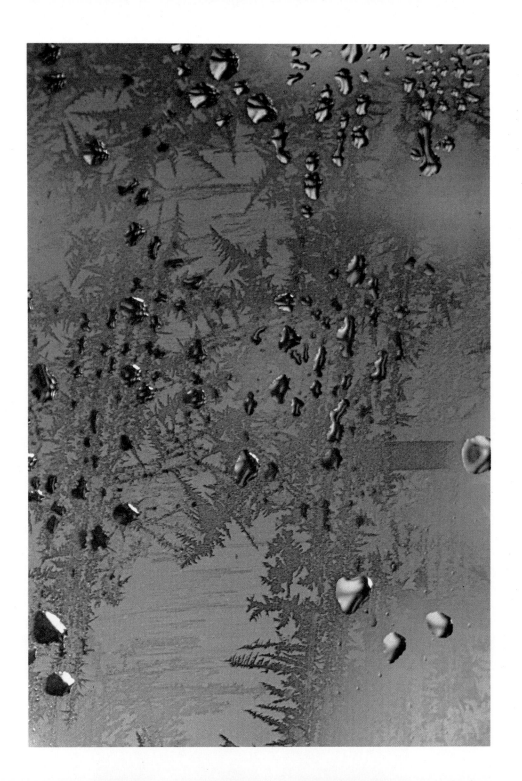

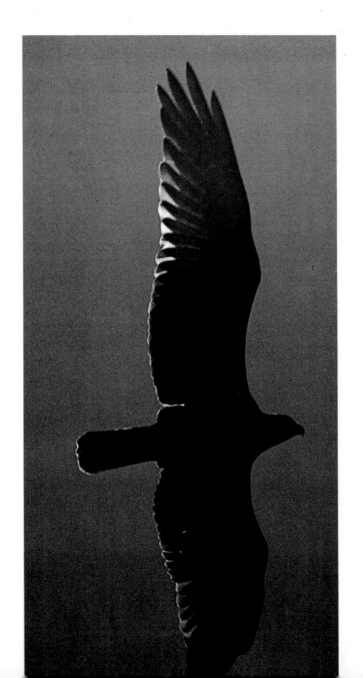

eternal sunrise, eternal sunset,

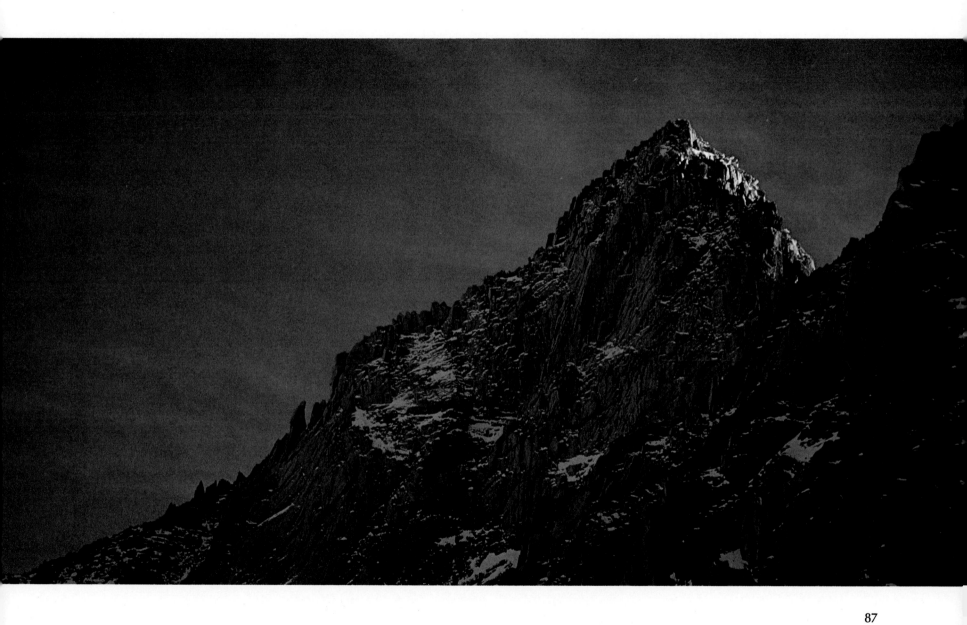

eternal dawn and gloaming, on sea
and continents and islands,

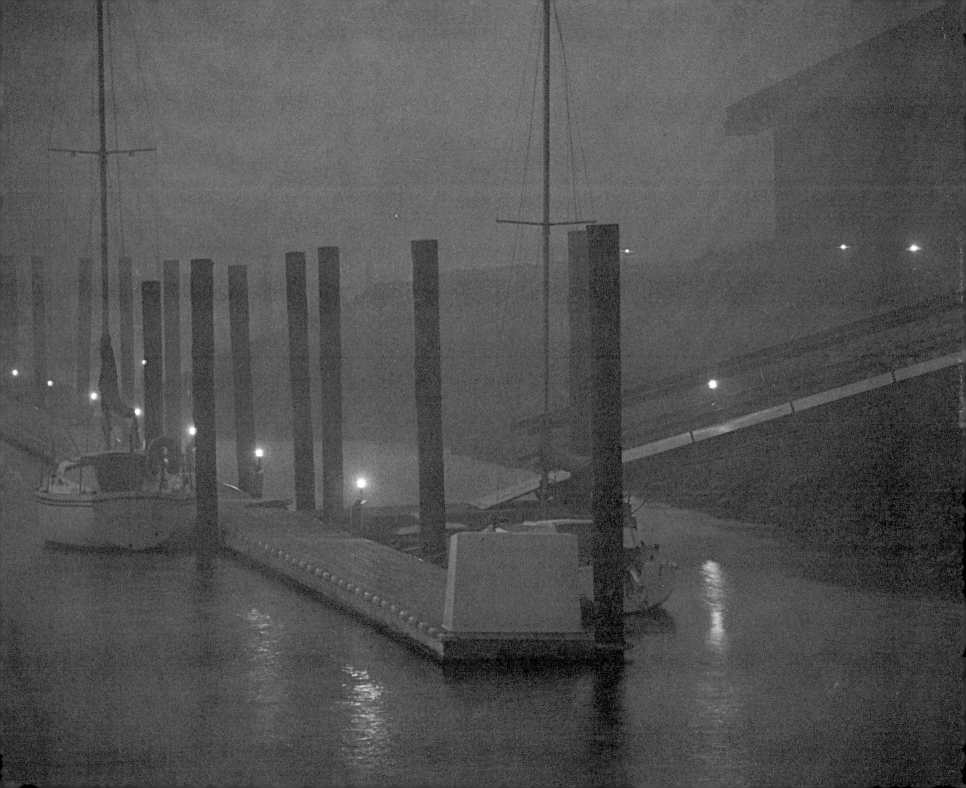

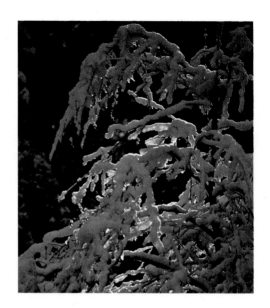

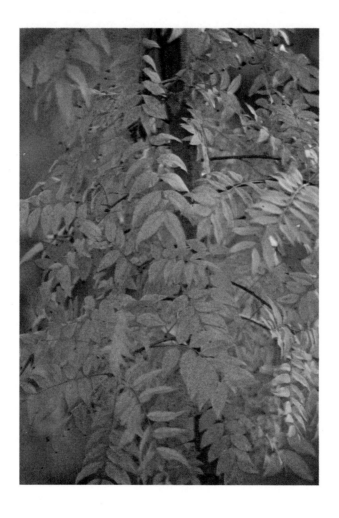

90

each in its turn,

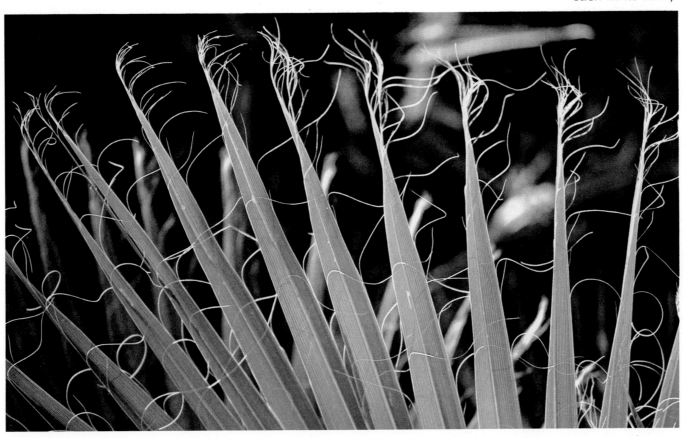

as the round earth rolls.

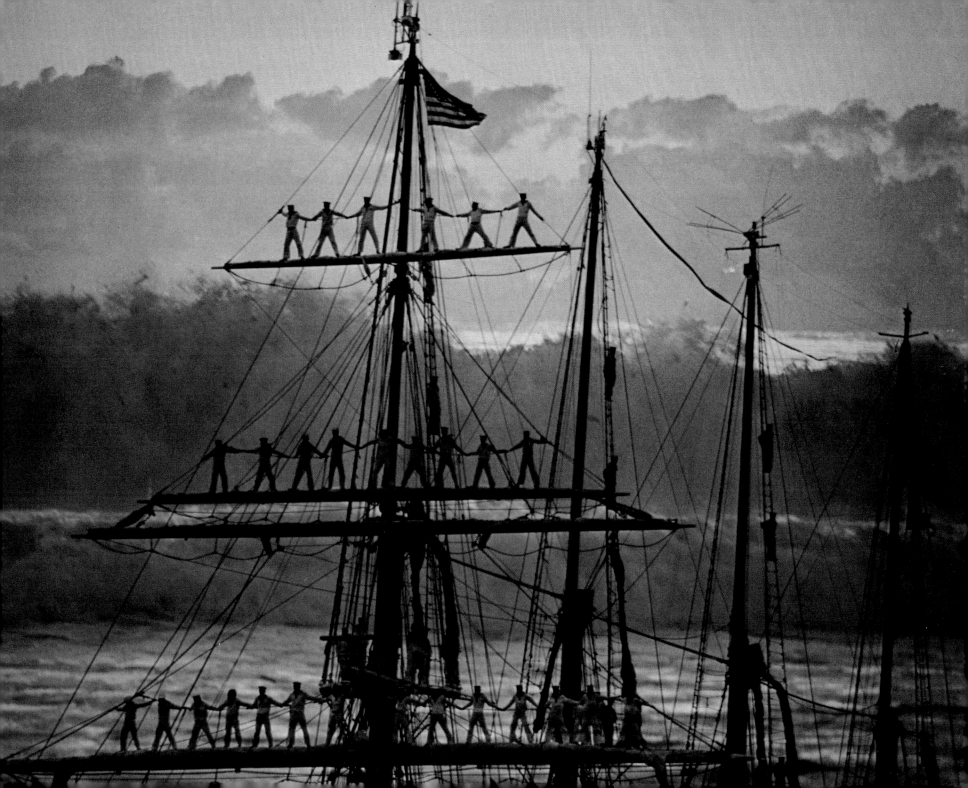

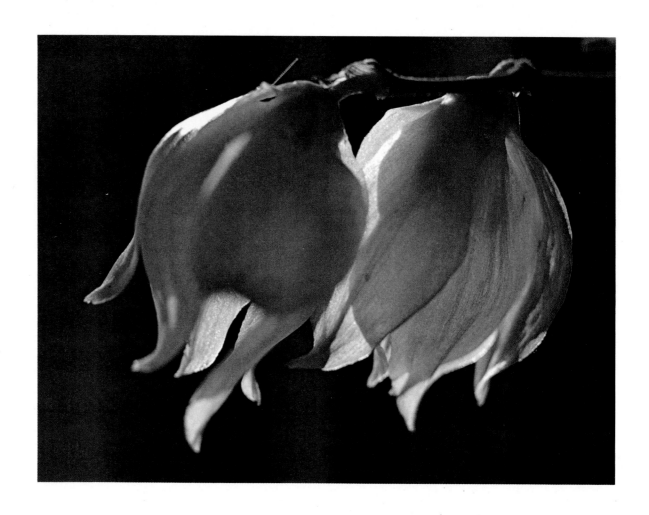

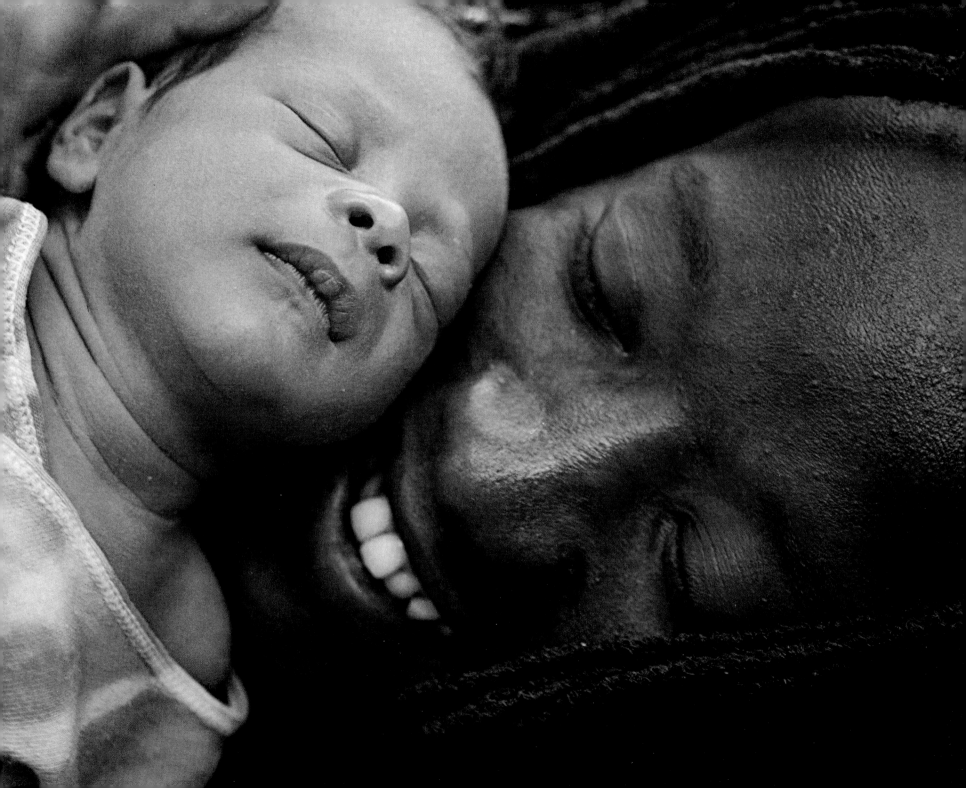

John Pearson — Born 1934…a Libra…minister's son…the South…protection, love, trust…one sister…routine hangups…college, graduate school…much information, little understanding…marry at twenty-five…move to California…Karen is born…Methodist minister two years…think about overpopulation, poverty, nuclear war…everything but my own life…What can I do?…Who am I?…quit…move to Berkeley…unemployed, overqualified…back to school…eight years of school, two degrees, no job…almost become a teacher…almost become a social worker…office worker for Berkeley Co-op…searching, boredom, despair…marriage falling apart…separation…divorce…depression, tranquilizers, analysis, shock therapy…thirty…come back…begin to try to save the world less and myself more…begin to trust my own feelings, do what I love…forget the princess, embrace the dragons…miracle…rebirth…hack photographer…little leagues, weddings, rainbow girls…a bummer but it's o.k.…the worse the outer world becomes the more I seek the inner world…thirty one-first good job…freedom, trust, expansion…money for film and paper…photograph what I love, on days off and weekends…help from friends, photographers, unexpected places…thirty-two live alone for first time and start first book…at a party I almost didn't go to I MEET LIZ…someone to share it all with…her place…my place…three weeks…our place…closer, deeper…begin to know my daughter better…first read Anais Nin's Diary…so personal, beautiful, true…several months later we meet, become friends…she encourages the journey I have begun…an incredible woman…thirty-four…*To Be Nobody Else* is published by a small press…many help, care, make it possible…leave of absence from my job…camping in Europe…new people…new nature…thirty-five…return to Berkeley…new perspectives, see what is close, near, overlooked…photograph…read…talk…listen…print pictures from Europe… expansion…exhaustion…sleep…more awareness of dreams…begin a new book…work mostly at night…changes…reactions, suggestions, revelations…changes…everyone close helps… fourteen hours in the darkroom…changes…*Kiss the Joy as it Flies* emerges…another leave of absence…camping across country…many national parks…begin to photograph more in color…re-read Whitman, Emerson, John Muir…start to work on *The Sun's Birthday*…rejected by ten publishers in three years…finally published in 1973…continue to photograph weekends, vacations, leaves of absence…travel in Everglades, Okefenokee swamp…return to Berkeley…discover beautiful children's writing…another new beginning…three years later *Begin Sweet World* is published…Karen comes to live with us…begin to get in touch with people more…photograph people more…thirty-nine…I am fired…unemployment checks, royalties, free lancing, and Liz working…I keep photographing what I love…September 1976…start to play with images…everything flows more than ever…magic doors open… Now forty-two…the future?…13,000 days left…more music…more poetry…more dreams…more dragons…more art…more nature…more life…

Photo by Karen Pearson

Many people helped with this book. Others influenced the serpentine paths that led to it. Thanks to: Liz Lamson; Karen Pearson, my parents; Anne Croswell; Johanna and Deane Lamson; Jenifer and Jaren Dahlstrom; Jo Pearson; Meri and Joe Ehrlich; Eugenia and Don Gerrard and Reneé; Chuck Morrell; Tom Baird; Ruth Bernhard; Wayne Miller; Paul Bragstad; Ed Brandstetter; Lucy and Dick Stoltzman; Susan, Larry and Eric Boulet; Lyn Sanny; Michael Hofmann; Linda and Hal Bennett; the Paul Taylor Dance Company; the Tubmakers; Marguerite, Lewis and Yohimbe; Anais Nin; Rupert Pole; Tom Robbins; Bill Douglas; Bob Routch; Sas Colby; Aspasia Nea and Celine; Camille LeCuyer; Ann Dilworth; and Pat Hatch.